IMAGES of America
LAKE TAHOE'S RUSTIC ARCHITECTURE

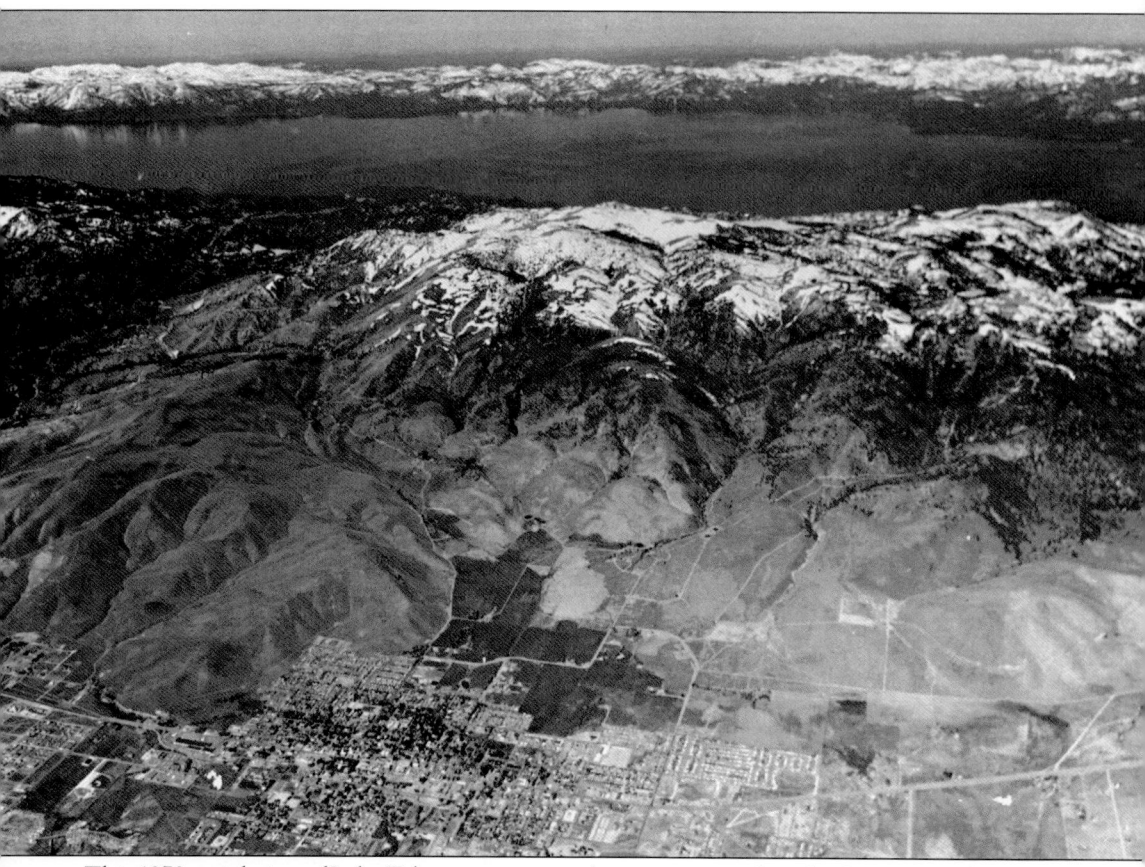
This 1972 aerial view of Lake Tahoe captures its alpine setting within the Sierra Nevada. Carson City, Nevada, is in the foreground and, looking west, the far shore is the California side of the "Lake of the Sky." The lake is 12 miles wide, 22 miles long, and 6,225 feet above sea level. (Nevada Historical Society.)

ON THE COVER: Thunderbird Lodge, built around 1941 on Tahoe's east shore, was the summer home of George Whittell Jr. Designed by Reno architect Frederic J. DeLongchamps, the home is listed in the National Register of Historic Places. Thanks to the Thunderbird Lodge Preservation Society, it is seasonally open to the public. (Special Collections Department, University of Nevada, Reno Libraries.)

IMAGES
of America

LAKE TAHOE'S RUSTIC ARCHITECTURE

Peter B. Mires
Foreword by Peter R. Dubé, NCARB, AIA

ARCADIA
PUBLISHING

Copyright © 2016 by Peter B. Mires
ISBN 978-1-4671-1654-1

Published by Arcadia Publishing
Charleston, South Carolina

Printed in the United States of America

Library of Congress Control Number: 2015955475

For all general information, please contact Arcadia Publishing:
Telephone 843-853-2070
Fax 843-853-0044
E-mail sales@arcadiapublishing.com
For customer service and orders:
Toll-Free 1-888-313-2665

Visit us on the Internet at www.arcadiapublishing.com

To my mentor, the late Dr. Fred B. Kniffen, who knew Lake Tahoe in the 1920s while a student at the University of California, Berkeley.

Contents

Foreword by Peter R. Dubé, NCARB, AIA		6
Acknowledgments		7
Introduction		8
1.	Tahoe's Rustic Roots	11
2.	Resort Rustic	25
3.	Residential Rustic	47
4.	Architects of Tahoe's Rustic Style	61
5.	Retail Rustic	79
6.	Religious Rustic	87
7.	Recreational Rustic	99
8.	Tahoe Style	111
Bibliography		127

Foreword

When Dr. Peter Mires asked me to write the foreword for this book, I thought back to one of my first projects fresh out of architecture school—the design of a new comfort station along the Tahoe Rim Trail. The site was typical of Tahoe's landscape: large boulders, towering trees, and rough terrain. Even as a budding junior architect, I instinctively understood my design had to blend with the natural setting.

That was 30 years ago. Long before me, architects and builders designed structures at Lake Tahoe in the rustic style. In this book, Dr. Mires takes the reader on a fascinating pictorial journey through the evolution of the Tahoe rustic style from early pioneer cabins to spectacular homes and resorts. Many of these outstanding extant examples of rustic architecture were designed by historically significant architects including Walter Danforth Bliss, Julia Morgan, and Bernard Maybeck.

Lake Tahoe's Rustic Architecture is a book about context as much as it is about architecture. Dr. Mires is a researcher who is always looking for "the why of where," and in the case of Lake Tahoe, that means trying to explain the rustic built environment in all its various permutations.

The mention of Tahoe's rustic architecture always brings to mind lakeside cabins and resorts. However, the images in this book show that the rustic style was not just expressed in residential buildings; stores, gas stations, churches, casinos, and even fish hatcheries around the lake incorporated rustic elements in their construction. This design vocabulary continues today, as some communities have in place policies to encourage and promote "mountain architecture" in both new and renovated commercial development.

Rustic has become Tahoe's brand. It is alive and well, and not something relegated to textbooks on architectural history. In fact, one might argue that rustic is more popular today than during its Gilded Age–to–Great Depression heyday. Historic preservationists believe this resurgence of interest in the rustic style—"mountain architecture" or "Tahoe style," if you prefer—comes from community identity and ownership. It is Tahoe heritage brought forward to the present with a sense of pride in the continuity of an iconic cultural landscape.

—Peter R. Dubé, NCARB, AIA
Dubé Group Architecture, Reno, Nevada

Acknowledgments

A number of individuals offered assistance and encouragement in areas other than photograph acquisition. They include: Michael "Bert" Bedeau, Jonah Blustain, Scott Challman, Sandra Hedicke Clark, Mary Cook-Rhyne, Peter Goin, Travis Hansen, Mella Rothwell Harmon, Ava Hinojosa, Scott Hinton, Kim Jackson, Ron and Susan James, Bob Kautz, Anne Leek, Mike Makley, David Parry, Jeff Paul, Jennifer Self, Nolan and Dee Smith, and Bill Watson. I would also like to thank fellow members of the Nevada Architectural History Alliance and the Lone Mountain Writers Group.

This book progressed from conception to publication thanks to three energetic members of the Arcadia Publishing team: Erin Vosgien, acquisitions editor; Sarah Gottlieb, title manager; and Katie Kellett, director of imprints.

While compiling *Lake Tahoe's Rustic Architecture*, I thought about the long trail that led me here. My affinity for rustic architecture has been lifelong, influenced by places and people. These include the Green Mountains of Vermont, a log cabin on a lake in Wisconsin, and a great-uncle who constructed some wonderful rustic buildings in the Adirondacks in the 1930s as a member of the Civilian Conservation Corps. I also thank Pete Dubé for contributing the foreword, and my family, especially Kim Grey, who shares my affection for the rustic architecture of the Lake Tahoe region.

A book such as this, which relies so much on archival photographs, is obviously indebted to numerous repositories and their staff. The people who helped me in my search for just the right photograph are legion, and I wish I could acknowledge each and every one of them. It is fair to say this book would not exist were it not for the following archives (abbreviations in parenthesis): Bernard Maybeck Collection, Environmental Design Archives, University of California, Berkeley (UCB); Lake Tahoe Historical Society (LTHS); Library of Congress (LOC); Massachusetts Institute of Technology Libraries, Institute Archives and Special Collections (MIT); National Register of Historic Places (NRHP); Nevada State Historic Preservation Office (NVSHPO); Nevada Historical Society (NHS); Nevada State Library and Archives (NSLA); North Lake Tahoe Historical Society (NLTHS); Julia Morgan Papers and Sara Holmes Boutelle Papers, Special Collections and Archives, California Polytechnic State University (JMP-CPSU and SHBP-CPSU); San Francisco History Center, San Francisco Public Library (SFPL); and Special Collections Department, University of Nevada, Reno Libraries (UNR). Photographs without attribution were taken by the author.

Introduction

Architectural historians use the term "built environment" to describe a cultural landscape of buildings and structures within a spatial context. Frankly, the image that comes to mind when those two words are juxtaposed is a human construction imposed upon a natural setting. The rustic architecture of the Lake Tahoe Basin belies that binary opposition insofar as the two merge into one on the landscape. Tahoe's rustic architecture is designed to blend into its surroundings by using natural materials such as logs, stone, and wooden shingle. Exterior colors are predominantly muted shades of green and brown. Landscaping is minimal, and often it appears as if the rustic building were somehow inserted into the local topography of trees, rocks, lakeshore, or mountainside. The aesthetic of rustic architecture, therefore, can be summed up in three words: harmony with nature.

"Rustic," as a word to describe this architectural style, has been in popular usage for more than a century. George Wharton James, who wrote the first guidebook to the Lake Tahoe region, *The Lake of the Sky: Lake Tahoe* (1915), used rustic repeatedly to describe both buildings and the ambiance of a place. It comes from the Latin *rusticus*, meaning rural, and when applied to architecture it implies compatibility with natural surroundings. Rustic may be capitalized if it is a specific reference to the architectural style and not simply used as an adjective. For the sake of simplicity, this book uses the lowercase rustic throughout.

It may be argued that rustic architecture has been around since our species first began using tools and building rudimentary shelters. The log cabin, that iconic rustic domicile of the American frontier, was transplanted from Scandinavia to the Eastern Seaboard in the early 17th century. As a deliberate and identifiable architectural style, however, rustic is more recent. It can be traced to the middle of the 19th century, particularly to the work of landscape architect Andrew Jackson Downing. Downing, who also had a penchant for Gothic Revival architecture as expressed in country cottages, advocated the use of natural materials in many of his designs.

The rustic style is easily identifiable because of attributes given above and elaborated upon throughout this book. It stands in contrast to other styles, many of which were designed to impress. This is especially true of buildings in urban settings where nature becomes inconsequential. The rustic style is, if anything, understated.

There is a popular association between the rustic style and resorts. Scenic mountains and lakes, particularly in the West, have their inviting lodges with a relaxing and back-to-nature ambience. The origin of the rustic resort, however, can be traced to the Adirondacks of upstate New York. Large hotels became summertime places of refuge and renewal for urbanites, particularly those from New York City, which, in the days before air-conditioning, could be none too pleasant from Memorial Day to Labor Day.

The association between the rustic style and a back-to-nature vacation also is attributable to the federal government. The National Park Service (NPS) and the US Forest Service (USFS) adopted the rustic style in the early decades of the 20th century, and many a park, camp, administrative

building, and interpretive center has characteristic elements of the style. For example, Yellowstone's Old Faithful Inn opened to public acclaim in 1904. Buildings in the rustic style at other high-visitation parks like Grand Canyon and Yosemite solidified the brand in public perception. Architectural historians John C. Poppeliers and S. Allen Chambers Jr., in fact, use the terms "parkitecture" and "government rustic" to describe how these federal agencies and the rustic style have become synonymous.

Rustic buildings proliferated nationwide during the Great Depression thanks to one of Pres. Franklin D. Roosevelt's New Deal programs. The Civilian Conservation Corps, or CCC, existed from 1933 to 1942. Its purpose was to give unemployed young men, more than half of whom were between the ages of 18 and 21, something meaningful to do. They were housed in military-style barracks, fed, and put to work on conservation-related projects, often for the NPS and USFS. Their legacy includes numerous rustic cabins, shelters, and campgrounds in parks and forests across the country.

The roots of rustic architecture in the Tahoe Basin go back to the 1850s. Although John C. Frémont and his fellow explorers saw and mapped the lake in 1844, and participants in the California Gold Rush passed by later in that decade, a few years elapsed before it became a destination. It is worth noting, however, that Lake Tahoe was central to the ancestral lands of the Washoe Indians, who camped there seasonally for millennia. The Washoe watched as their homeland was taken up by outsiders who came to the lake for reasons other than subsistence and scenery, an all-too-familiar refrain in American history.

Ironically, it was not the rush west by the Forty-Niners and others that stimulated settlement around the lake; it was the rush east, back over the Sierra to the Comstock Lode in Utah Territory 10 years later. Silver was discovered in 1859 in the vicinity of what became one of the greatest mining towns in the West—Virginia City. A hoard of miners from California's Mother Lode country rushed in, and with them came the necessity for all manner of provisions. Soon there was regular traffic over the Sierra. One of the busiest routes went from Placerville, California, to the Comstock by way of the lake's south shore. As a consequence, stage stations, hotels, and cabins were built to accommodate travelers, and two stations even briefly served the Pony Express.

The first community of any size on the lake was Glenbrook, initially a center for industrial lumbering whose market lay 30 miles to the northeast. The Comstock communities, particularly Virginia City and Gold Hill, had an insatiable appetite for lumber and firewood, but the mines in particular required enormous quantities of wood to shore up shafts, tunnels, and large cavities after the removal of ore bodies. *Territorial Enterprise* editor Dan De Quille put it succinctly: "The Comstock lode may truthfully be said to be the tomb of the forests of the Sierras."

The era of Comstock mining and Tahoe lumbering came to a close by the 1890s, as both silver ore and standing timber were exhausted. It was replaced up at the lake by the growing popularity of rustic summer homes and resorts, and once again, the focus shifted to the west. Lake Tahoe became the playground for San Franciscans, particularly the wealthy, who bought property on the California side and built vacation homes. Others were drawn to the hotels and rustic lodges offering all manner of relaxation and recreation—boating, swimming, fishing, hiking, horseback riding, nature study, or simply sitting on the veranda with a good book. George Wharton James made the distinction between mountain and lake resorts depending on their proximity to Tahoe's lakefront, Rubicon Springs and Glen Alpine Springs being examples of the former, while the latter included Lucky Baldwin's Tallac Hotel, the Grand Central Hotel in Tahoe City, and the Glenbrook Inn.

The reputation of Lake Tahoe as a world-class tourist destination solidified at the beginning of the 20th century with two developments: a railroad connection to the lake and the construction of Tahoe Tavern. Former lumber baron Duane L. Bliss may have had an epiphany when he suddenly recognized the beauty of the lake after cutting the surrounding forest; more likely, he was a shrewd businessman who saw opportunity in tourism. In any event, he removed the tracks from his Glenbrook operation and created a narrow-gauge railroad connection between Truckee's Southern Pacific station and the Tahoe Tavern pier a half-mile south of Tahoe City. Tahoe Tavern,

designed in the rustic style by his architect son Walter Danforth Bliss, was constructed in 1901 and became an instant landmark. According to Edward B. Scott's *The Saga of Lake Tahoe* (1957), "the Tavern, with its brown shingled exterior, wide porches and stretches of lawn and flower beds, became the show place of Tahoe."

Another significant punctuation in the development of Lake Tahoe was the rise of the automobile in the 1920s and the completion of a road encircling the lake in 1925. The affordability of the automobile meant prospering middle-class vacationers could come up to the lake in much greater numbers. Car camping became popular, as did a stay in rustic lodges and campgrounds offering tent and cabin accommodations. Places like Zephyr Cove Resort and Camp Richardson, both still in business, satisfied the market.

The Great Depression and World War II significantly slowed visitation and development. One individual, however, made a lasting impact on Lake Tahoe's landscape. In 1936, millionaire George Whittell Jr. purchased 45,000 acres of former timber holdings, including those of the Carson and Tahoe Lumber and Fluming Company. This included more than 20 miles of lakeshore on the Nevada side, roughly a third of Tahoe's total shoreline. Near Sand Harbor the reclusive Whittell built his summer sanctuary, Thunderbird Lodge, a rustic-style estate designed by Reno architect Frederic J. DeLongchamps. The compound of buildings is now owned by the nonprofit Thunderbird Lodge Preservation Society, but most of the land is state park and national forest, which accounts for the dearth of development between Incline Village and Zephyr Cove.

The Native American stonemasons who exhibited their craftsmanship at Thunderbird Lodge also were responsible for rustic architecture elsewhere in the Lake Tahoe region, notably in the community of Zephyr Cove. They had learned their trade at the Stewart Indian School in nearby Carson City and found their skills in great demand up at the lake. These cottages are as sturdy today as the day they were built and remain a tribute to local Washoe Indians, who otherwise left little trace of their people's long occupation of the lake they called *Da ow*.

After World War II, Lake Tahoe changed in some dramatic ways, the most obvious being that it became a year-round resort with a growing resident population. Contributing to this were hotel casinos and winter sports. Nevada legalized gambling in 1931, and later that decade, the rustic Cal-Neva opened. Built astride the California-Nevada state line at Crystal Bay, the gambling took place on the Nevada side of the establishment. Stateline casinos, notably Harrah's and Harvey's, followed, and their high-rise hotels now dominate the skyline. Ski resorts at Lake Tahoe can be traced to Granlibakken and Squaw Valley in the north and Heavenly Valley in the south. The 1960 Winter Olympic Games at Squaw Valley forever established Lake Tahoe as a premier winter sports destination. Consequently, by 1963, Lake Tahoe had a resident population of 16,000, and exponential growth has persisted into the 21st century.

Preserving Lake Tahoe's natural and cultural resources is the greatest challenge facing the region today. The legendary clarity of the lake is in jeopardy because of pollutants and development-related sediments, and the rustic built environment is being overpowered by construction less in harmony with its surroundings. In 1915, George Wharton James wrote, "provisions for the entertainment of travelers, yearly visitors, and health seekers will speedily increase with the years there can be no doubt, for there is but one Lake Tahoe, and its lovers will ultimately be legion." James promoted the lake as a booster and must have felt the legion of Tahoe lovers would do whatever was necessary to preserve this unique and wonderful place. Historic preservationists enamored of its rustic architecture could not agree more.

One

TAHOE'S RUSTIC ROOTS

In a recent and magnificent exhibit, *Tahoe: A Visual History* (August 22, 2015–January 10, 2016), the Nevada Museum of Art presented the story of Lake Tahoe through various media—basketry, painting, sculpture, photography, and architecture among them. Not surprisingly, the story was told in roughly chronological fashion beginning with the Washoe Indians. Washoe occupation of Lake Tahoe continues to the present, albeit in a much different way than in times past, and in terms of architecture, their imprint remains in subtle yet recognizable elements. The Washoe built temporary conical shelters clad with the bark of one of Tahoe's iconic tree species, incense cedar (*Libocedrus decurrens*). Incense cedar has remained a popular cladding material, as numerous photographs in this book show. In overall form and style, however, Tahoe's rustic roots are decidedly European American.

The earliest buildings at Lake Tahoe, those from the 1850s and 1860s, were simple vernacular constructions made from log or lumber. The people who built them migrated, by and large, from the Eastern United States and brought along a mental template of folk housing forms. By this time, balloon framing had replaced heavy timber construction, and some Tahoe photographs from the time show two-story stagecoach stations or hotels that would not have been out of place elsewhere in the country.

The place that had the greatest influence on early Lake Tahoe architecture was Virginia City, Nevada, and associated Comstock Lode communities. Wood was a scarce commodity in the deserts east of the High Sierra, and the widely dispersed stands of piñon pine and juniper surrounding Virginia City amounted to nothing more than firewood. The first actual settlements in the Tahoe Basin, therefore, were lumber camps in the service of the Comstock (although there was a brief gold rush in the vicinity of Squaw Valley). With the local availability of milled lumber, other buildings such as resort hotels soon made their mark on the Tahoe landscape. As a consequence, wood, either milled into lumber or used as logs, constituted the basic building material in the Tahoe Basin. Coupled with an abundance of granite cobbles and boulders for foundations, buttresses, and chimneys, the roots of Tahoe's rustic architecture were established.

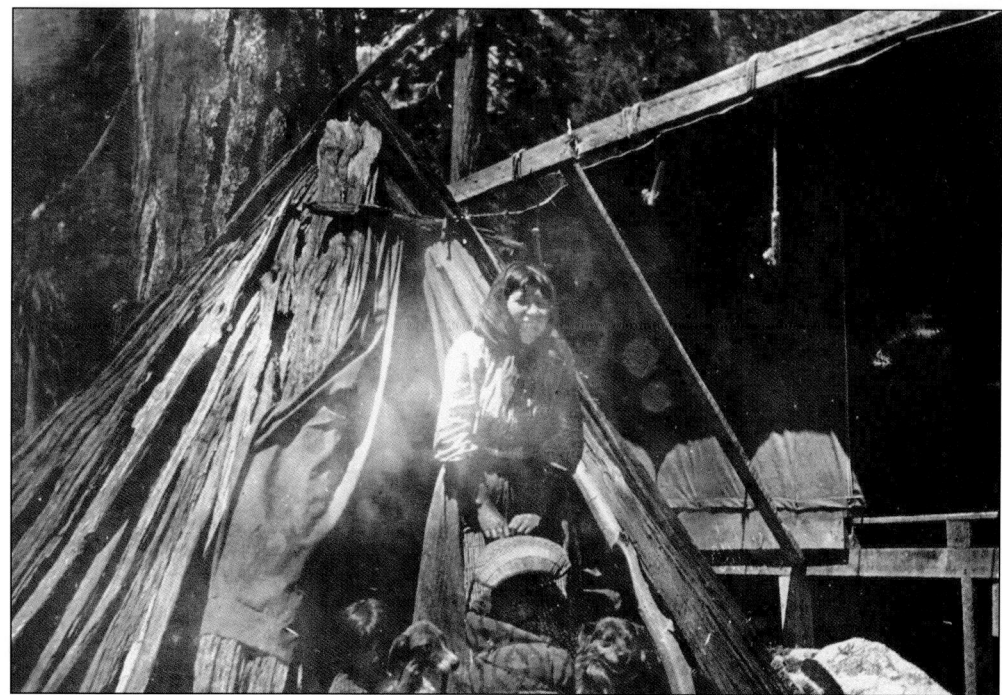
This 1906 photograph is an example of the traditional Washoe cedar-clad conical shelter. European Americans adopted the use of incense cedar because of its rot-resistant property. Slabs of cedar bark were often attached to exterior walls as vertical siding and sometimes used as interior paneling, and cedar shakes were a preferred roofing material. Pictured are Lottie Kyser and her children at Emerald Bay. (UNR.)

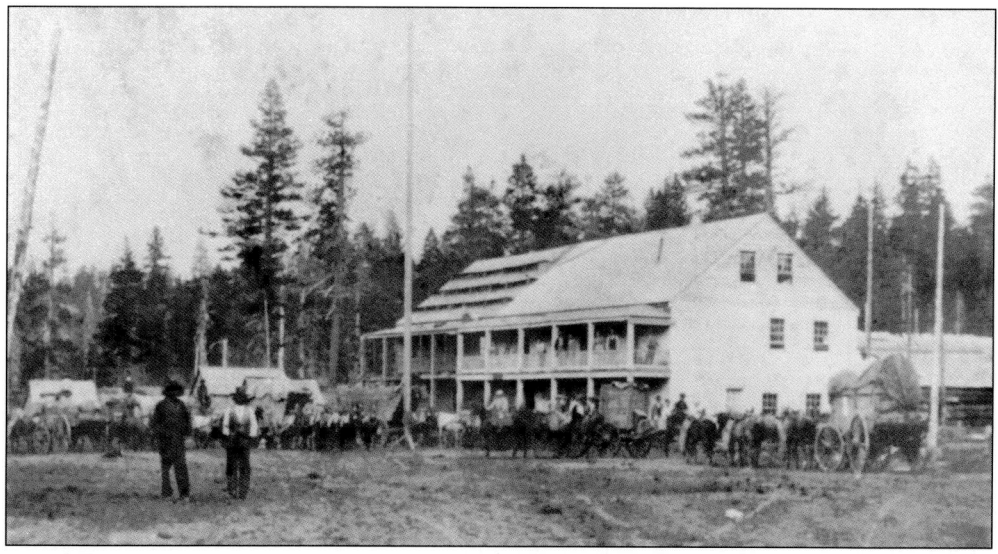
Initial European American settlement of Lake Tahoe was largely a response to the discovery of the Comstock Lode in Nevada in 1859. The Bonanza Road, which connected Placerville, California, to Virginia City, Nevada (then part of the Utah Territory), skirted Lake Tahoe's south shore. Stations, such as this one operated by Ephraim "Yank" Clement, accommodated the heavy stage and wagon traffic. (LOC.)

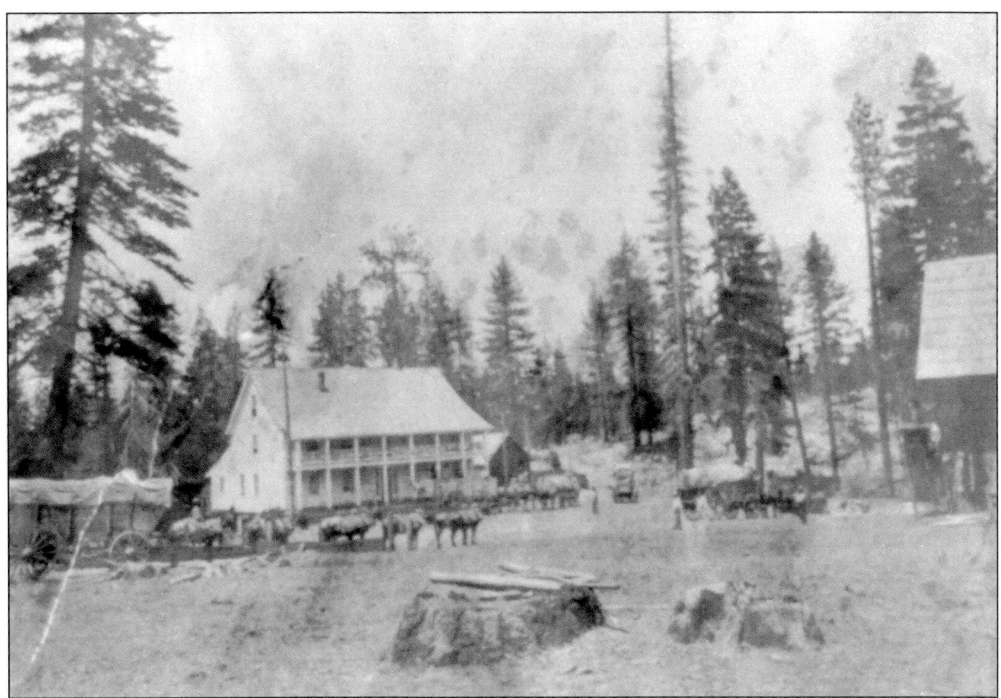

Like Yank's Station, Friday's Station, named for Martin K. "Friday" Burke, was another important location along the Bonanza Road. A one-room log cabin served as the first station, but the large frame building shown here, which still stands near Stateline, was quickly built to meet the demand for lodging. Friday's also served as a Pony Express station from 1860 to 1861. (LOC.)

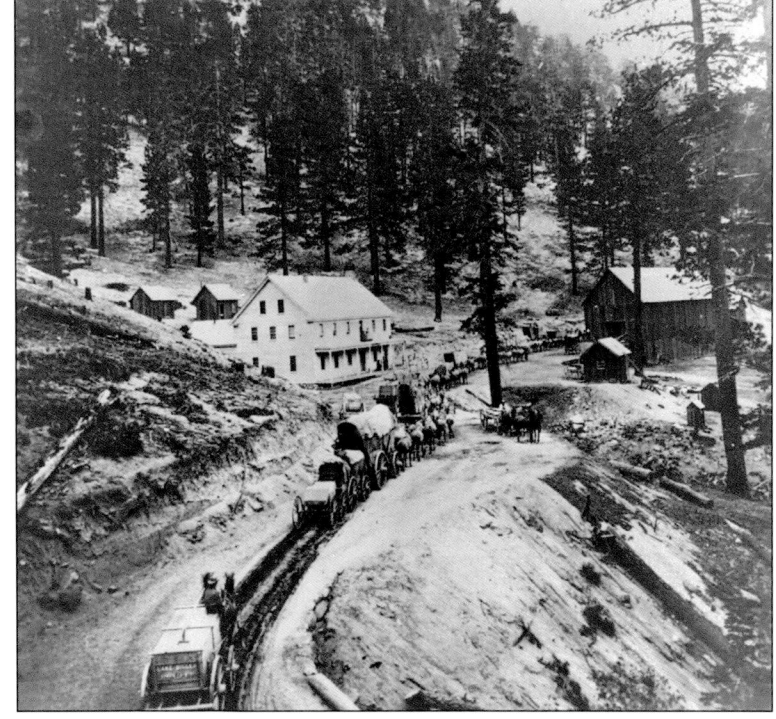

This c. 1860 photograph taken near Glenbrook gives an idea of the wagon congestion along the Bonanza Road. Within a decade, however, the railroad—first the Central Pacific, which followed a Donner Pass route over the Sierra, supplemented later by the Virginia & Truckee—would siphon off most of the traffic between California and the Comstock. (UNR.)

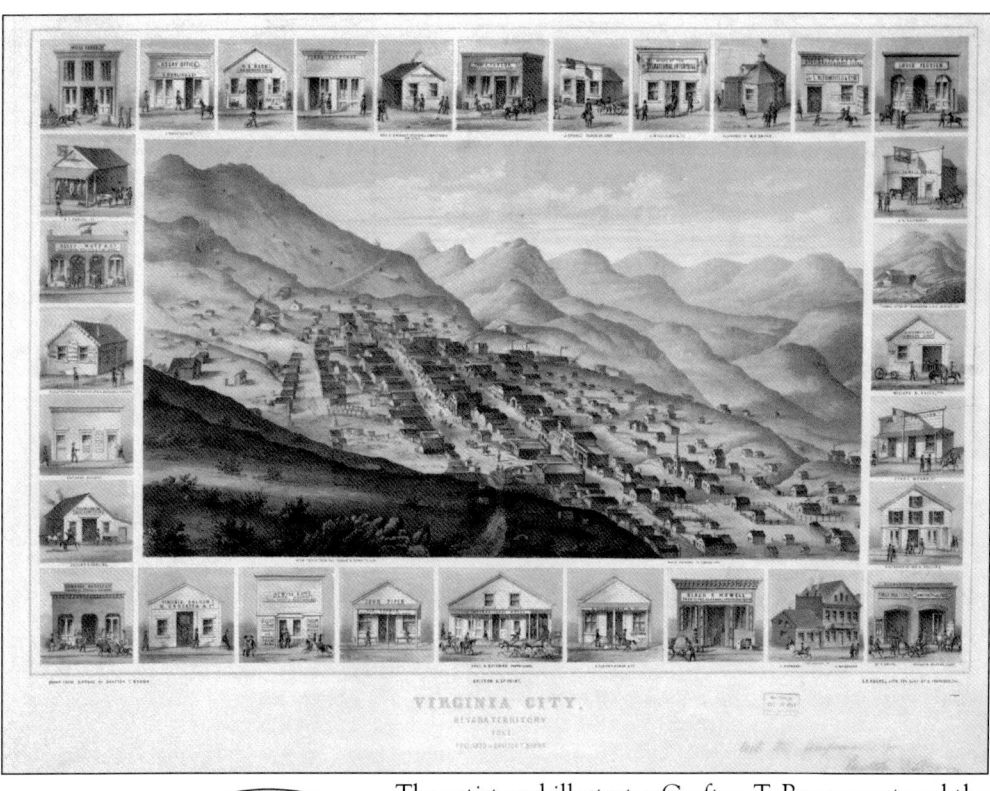

The artist and illustrator Grafton T. Brown captured the boomtown of Virginia City in 1861 through his bird's-eye view from the Gould & Curry mining claim. The commercial and residential buildings that form the border are doubly impressive considering that two years earlier, the first miners were living in canvas tents and hillside dugouts. This place explains why the Bonanza Road up at Lake Tahoe had so much traffic. (LOC.)

Samuel L. Clemens, also known as Mark Twain, loved Lake Tahoe, and his 1861 adventures up at the lake were memorialized in *Roughing It*. Twain's writing resonates to this day, and quotes such as the following have been oft repeated: "The air up there in the clouds is very pure and fine, bracing and delicious. And why shouldn't it be?—it is the same the angels breathe." (LOC.)

Dan De Quille, an editor with Virginia City's *Territorial Enterprise*, remarked: "The Comstock lode may truthfully be said to be the tomb of the forests of the Sierras." He meant specifically Lake Tahoe's old-growth timber. As this 1876 drawing by T.L. Dawes illustrates, the Comstock mines required large, interlocking, milled-lumber networks called square sets to facilitate the extraction of ore. (LOC.)

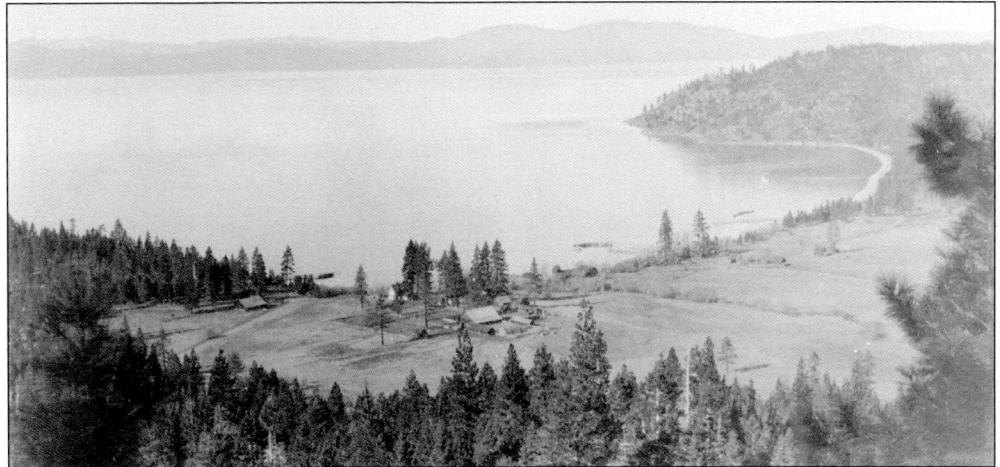

Glenbrook, on Lake Tahoe's east shore, became an early center for industrial lumbering. As president and general manager, former banker Duane L. Bliss supervised the operations of the Carson and Tahoe Lumber and Fluming Company. Glenbrook gained fame as well for being home to one of the lake's most popular hostelries, Glenbrook Inn, which remained under Bliss family management until it closed in 1976. (UNR.)

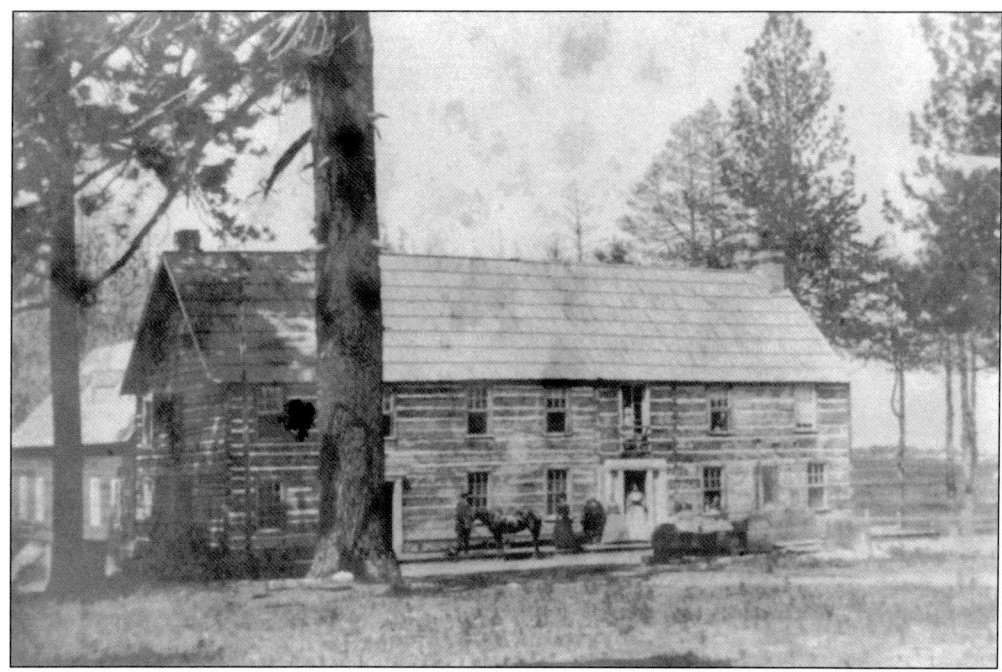

Lake House was the first hostelry on the shores of Lake Tahoe. It was built in 1859, in time for the "Rush to Washoe," as the Comstock region was called. J. Ross Browne, who witnessed the crush of those expecting food and lodging, described the scene for *Harpers Magazine* as "a bedlam of disorganized confusion." By 1865, when these photographs were taken, the frenzy of "maddened gold seekers" to be the first on the scene and stake their claim had subsided. In its place was a more genteel clientele, however incongruous the juxtaposition of the well-dressed couple and the rudimentary log hotel may seem. Note the white-painted entrances, brick chimneys at the gable ends, and wide cedar-shake roof. (Both, LOC.)

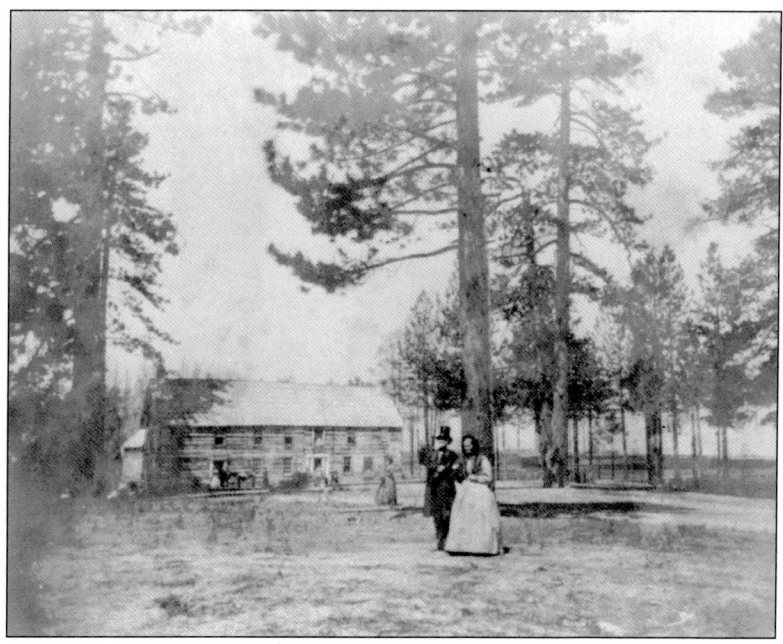

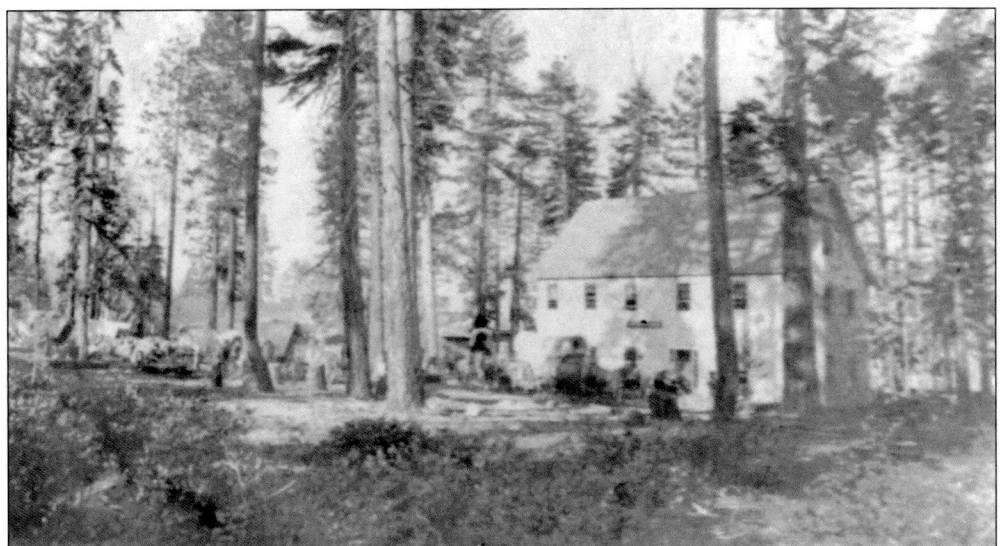

Zephyr Cove House, another early 1860s Bonanza Road hostelry, went out of business by 1869, when traffic, and customers, became negligible. Owner Andrew Gardinier (later Gardner) sold his 160-acre homestead, which included the hotel, to Capt. Augustus Pray, who wanted the standing timber on the property. By 1871, the *Carson City Appeal* called the Zephyr Cove House, "a vestige of a by-gone era." (LOC.)

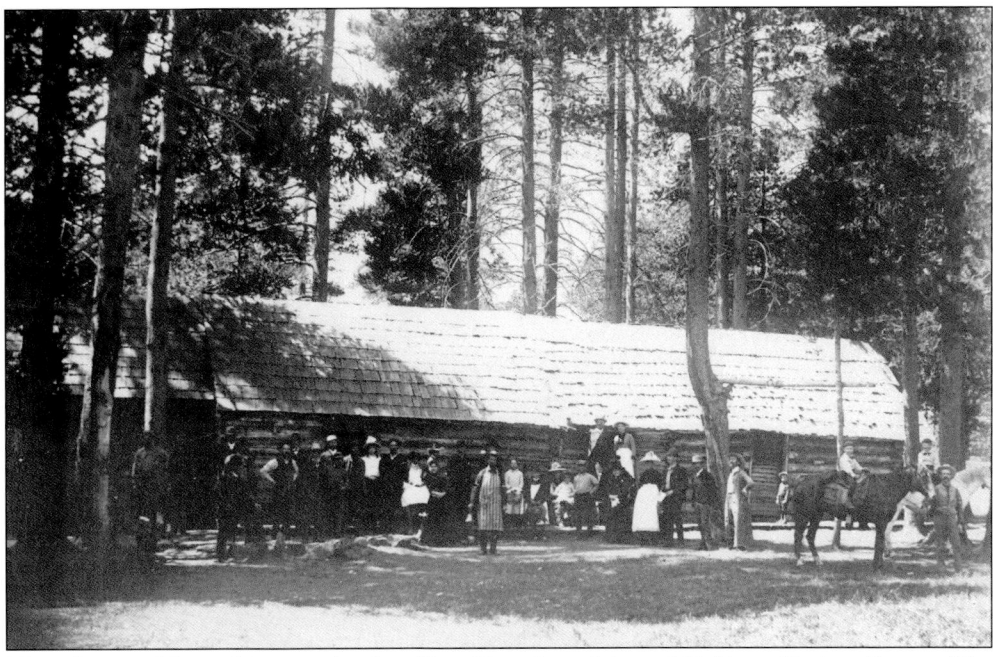

This elongated log cabin was the first "hotel" at the celebrated Rubicon Springs Resort. The springs, known to the Washoe for generations, were developed in the 1860s by the Hunsaker brothers. Sierra Nevada Phillips Clark bought Rubicon Springs in 1886 and built a large frame hotel. In 1915, George Wharton James described it as "one of the oldest and most famous resorts in the High Sierras." (UNR.)

One of the first permanent residents of Lake Tahoe's west shore was Gen. William Phipps, who in 1860 claimed a 160-acre homestead near Sugar Pine Point. Phipps, a Kentucky native and veteran of the Plains Indian Wars, initially built an "old log and shaker" cabin on the left bank of General (also Phipps) Creek where it enters the lake. This is a photograph of Phipps's second cabin, which, as can be seen from the inscription below, was built in 1872. Phipps died in 1887; Isaias W. Hellman acquired the property 10 years later and built Pine Lodge, also known as the Hellman-Ehrman Home. The cabin is now an interesting ancillary to the interpretation of the Hellman-Ehrman Estate by California State Parks.

As with Rubicon Springs, the story of Glen Alpine Springs above Fallen Leaf Lake figures into Tahoe's rustic roots from the 1860s. These photographs are of a replica of the rustic shelter for one mineral spring at the Gilmore's Glen Alpine Springs Resort and a plaque on the Chapel of St. Francis of the Mountains acknowledging Tahoe pioneers Nathan Gilmore and I.B. Richardson. The origin of the name Glen Alpine is interesting: according to Barbara Lekisch's *Tahoe Place Names* (1988), "Gilmore's wife, Amanda Gray Gilmore, chose the name Glen Alpine from Sir Walter Scott's romantic poem *Lady of the Lake*."

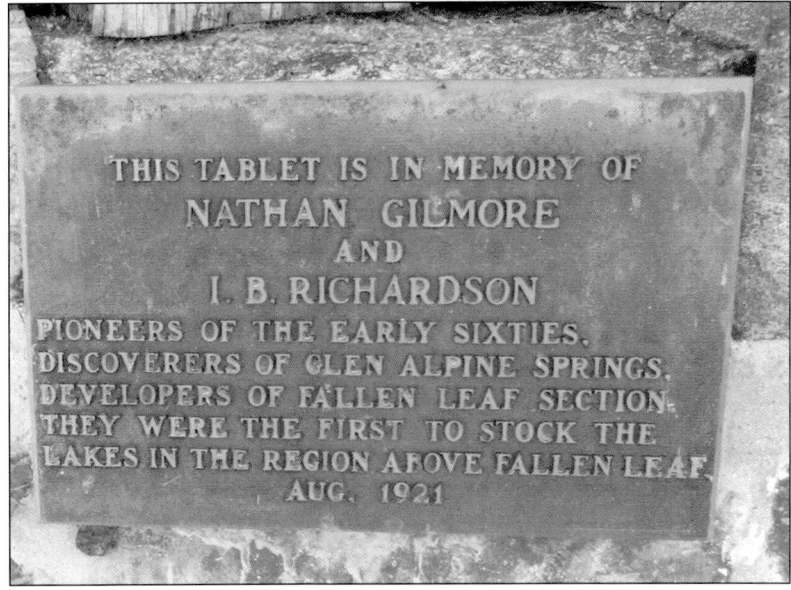

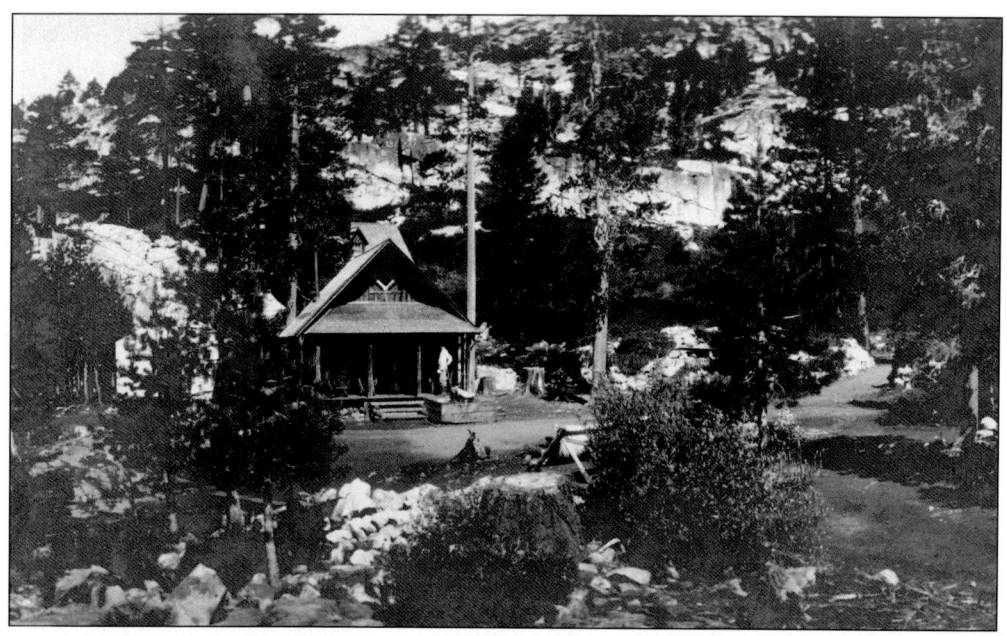

This c. 1911 photograph vividly illustrates the physical setting of Glen Alpine Springs. Part of its appeal, besides the springs and comfortable rustic cabins, was the dramatic once-glacial landscape praised in an 1875 journal article by Dr. Joseph LeConte: "On ascending the canyon the glaciation is very conspicuous, and becomes more and more beautiful at every step." (UNR.)

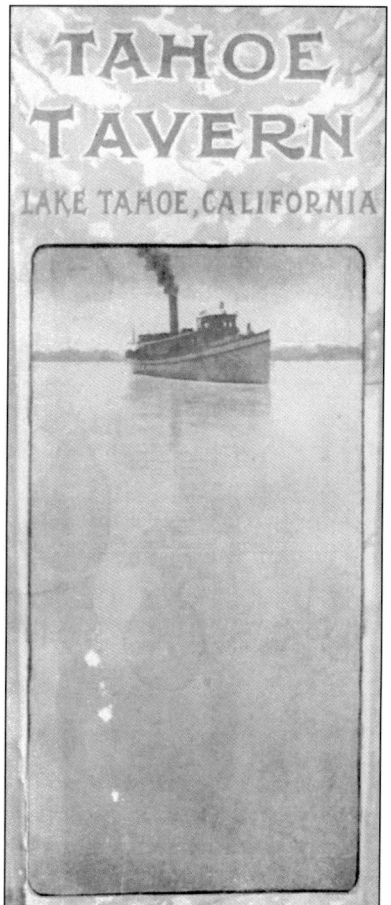

This c. 1911 brochure for the Tahoe Tavern suggests another aspect of Tahoe's rustic roots—a time when the best way to get around the lake was by boat. The steamer *Tahoe* circumnavigated the lake once a day, picking up and dropping off passengers, mail, and all manner of supplies. (NLTHS.)

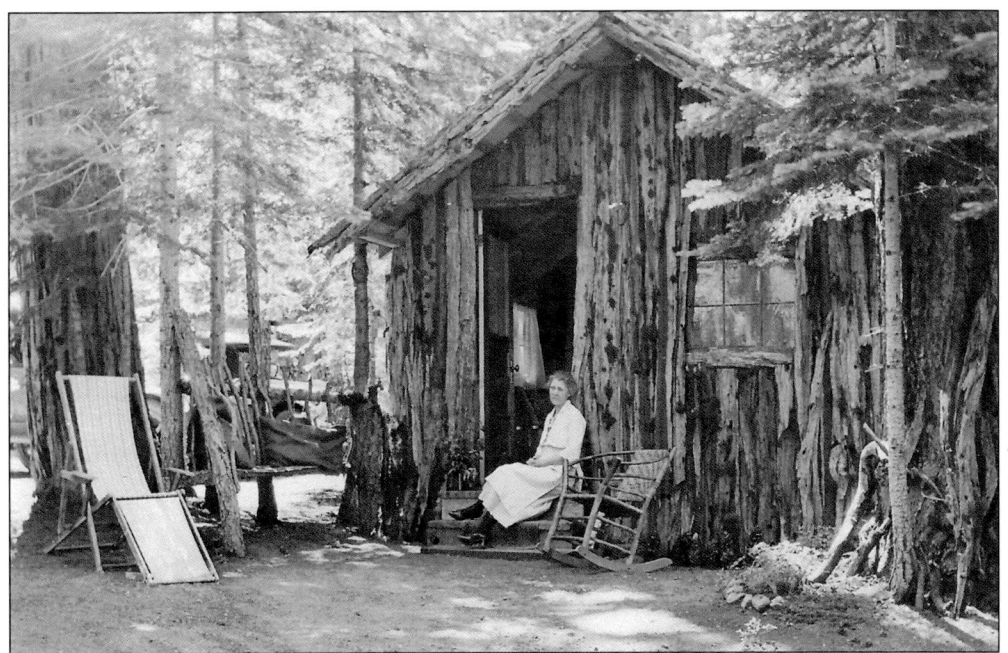

Known as Valentine's bark shack, this whimsically rustic one-room, front-gabled, frame building, or "shack," was covered entirely with local cedar bark. It sat in the trees behind Tahoe Tavern and must have delighted hotel guests walking the grounds. Some, perhaps even this unidentified woman, may even have felt inclined to sit a spell. (NLTHS.)

The Watson Cabin, located on North Lake Boulevard in Tahoe City, is representative of Lake Tahoe's early rustic log-cabin architecture. Constructed in 1908 and now listed in the National Register of Historic Places, this property is maintained by the North Lake Tahoe Historical Society and is open to the public seasonally. (NLTHS.)

The rustic roots of Tahoe Basin architecture include diminutive fishing camps such as this one on Fallen Leaf Lake. This photograph gives new meaning to having a solid foundation. Fallen Leaf Lake, as a glacial remnant, has a relatively steep shoreline, and there are many cabins around the lake perched on a slope, but this is clearly something of an exception. (NLTHS.)

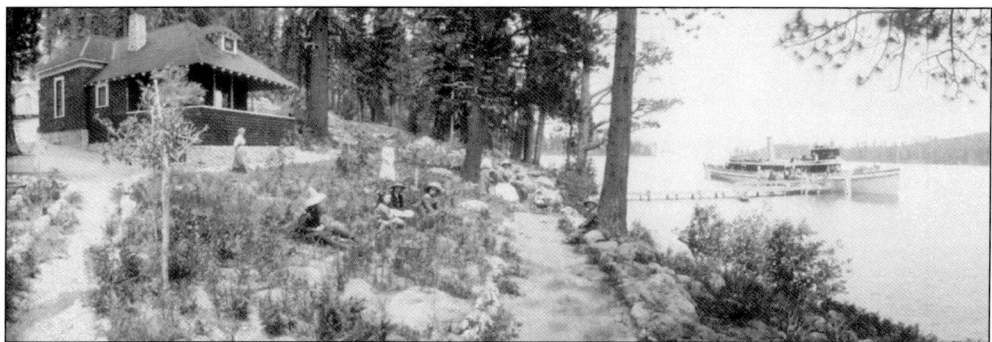

In this panoramic view, the steamer *Tahoe* can be seen either discharging or boarding passengers on an Emerald Bay pier. Prominent in the photograph is an early-20th-century Craftsman-style bungalow with shingled walls, exposed rafter tails, fully engaged wraparound porch, and hipped roof and dormer. Rustic elements include the stonework chimney and foundation. Note the canvas tent immediately behind the house. (LOC.)

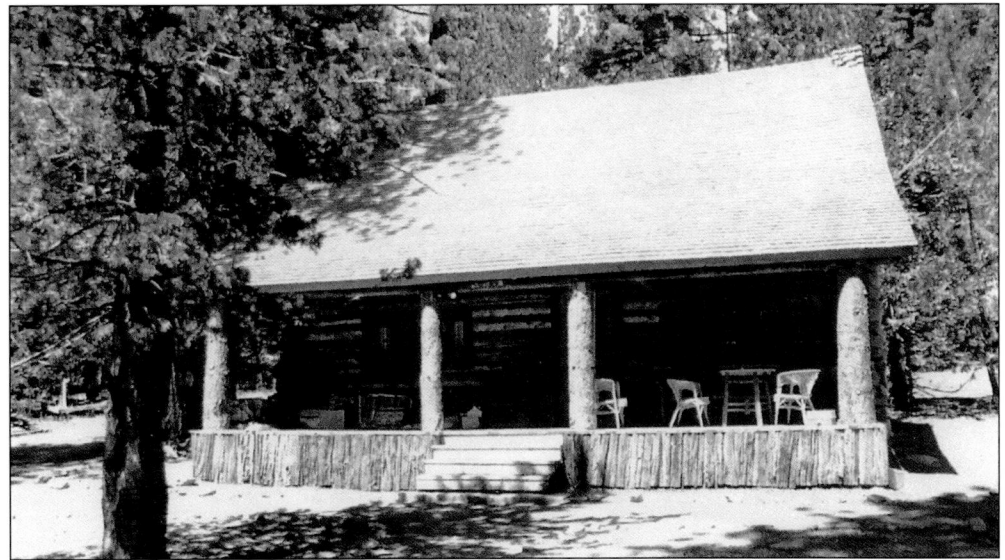

Pictured is one of the cabins built by brothers George and Jim Murphy and their brother-in-law Luke Morgan on Meeks Bay. It was built in 1920, and this photograph was taken in 1986, after its restoration. The Murphy brothers came to Tahoe in 1872, operated McKinney's Resort for many years, and eventually bought property nearby where they and Morgan constructed cabins. This is one of five extant cabins still in the family. (NLTHS.)

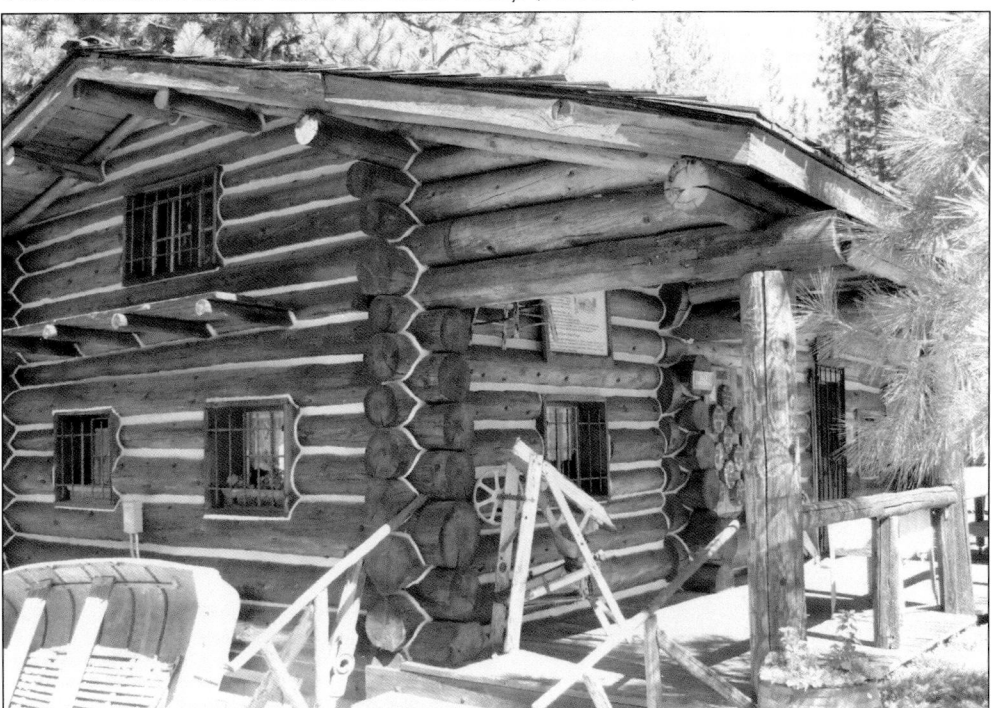

The Pomeroy Cabin, built in the 1930s, was for many years the summer home of the Gruener family until they sold it to the City of South Lake Tahoe in 1968. It became the Log Cabin Museum and from 1970 to 1983 was the headquarters of the Lake Tahoe Historical Society. In 1991, the cabin was moved several blocks, and is now part of an expanded Lake Tahoe Museum complex.

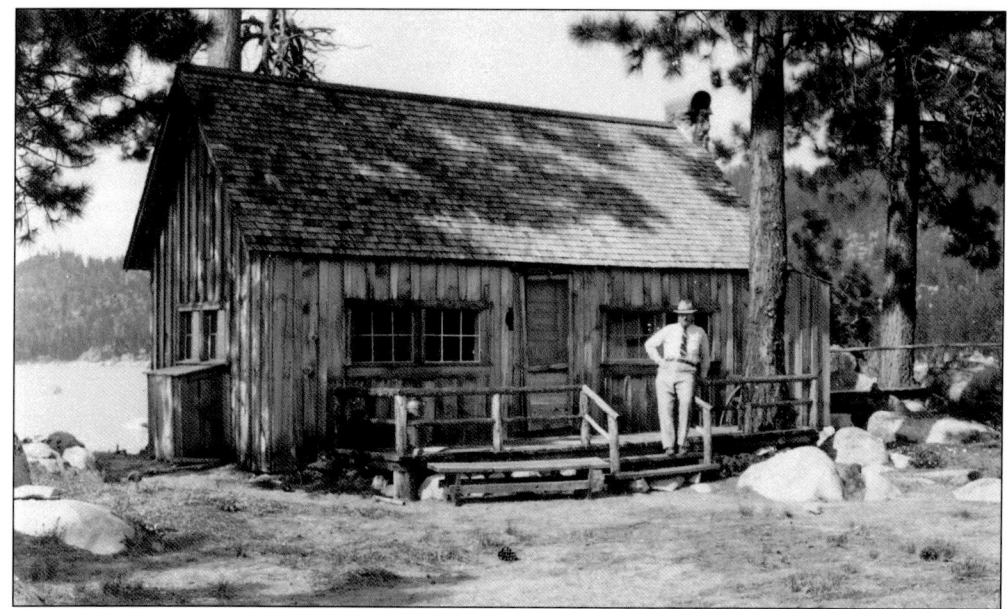

Skyland Camp was an early resort north of Zephyr Cove, a place still known for rustic rental cabins. Here, a man stands on the porch of just such a cabin around 1938. Note the board-and-batten construction, gable-end chimney, and functional porch suggesting simple yet comfortable accommodations. Also typical is the lack of landscaping; most Tahoe cabins were constructed so as to accommodate pre-existing rocks and trees. (UNR.)

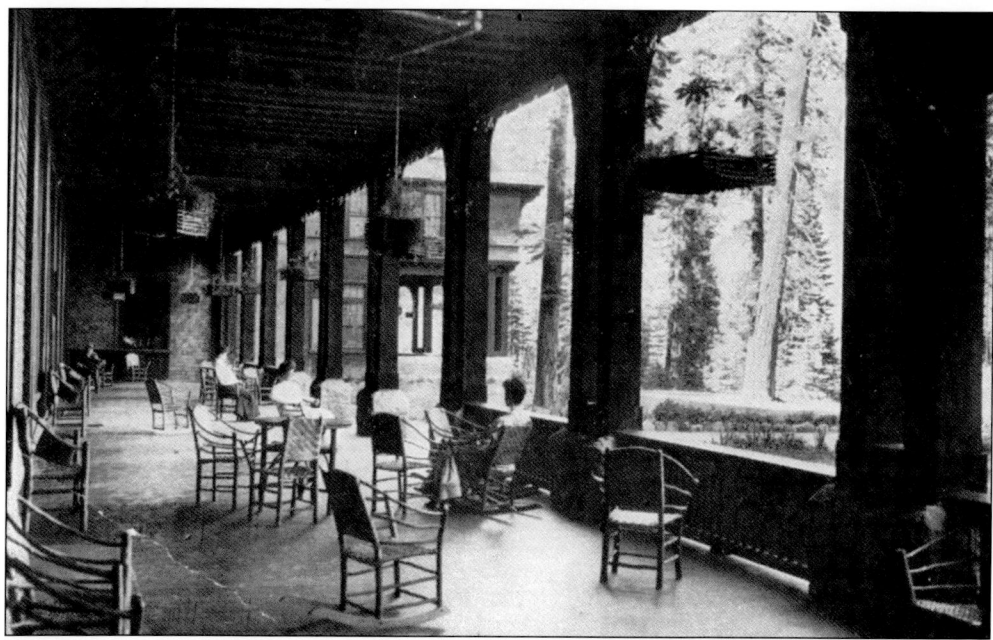

The most popular part of any resort was the veranda, and this was especially true of the famed Tahoe Tavern near Tahoe City, shown here around 1906. Guests would read, socialize, or just enjoy the view, which could be either tranquil or heavily trafficked. Tahoe Tavern's pier was where the train from Truckee met the steamer that circumnavigated the lake in the days before reliable roads. (UNR.)

Two

Resort Rustic

For the Lake Tahoe region, resort rustic is practically a redundant term. Even E.J. "Lucky" Baldwin's Tallac Hotel, billed as "the Saratoga of the Pacific," cultivated an elegant rustic reputation. An 1882 piece in the *San Francisco Alta* used the adjective rustic to describe the hotel's natural surroundings rather than its architecture per se: "Tallac is rustic and comfortable as well as commodious, with a white sand beach running one-half mile west, yet the only signs of civilization are the hotel and wharf, so carefully have the natural beauties of the grounds been preserved." As resorts went, the Tallac Hotel was "genteel and tony," but most guests followed George Wharton James's later advice concerning a Tahoe resort stay: "While it is very delightful to sit on the veranda . . . One must get out and feel the bigness of it all; climb its mountains, follow its trout streams; ride or walk or push one's way through its leafy coverts; dwell in the shade of its forests; row over its myriad of lakes; study its geology, before he can know . . . Tahoe."

Many resorts were truly rustic in both setting and architecture. These are best exemplified by resorts in the vicinity of Fallen Leaf Lake, a glacial remnant one mile south of Lake Tahoe at Tallac. Glen Alpine Springs and Fallen Leaf Lodge appealed to those who did not count themselves among the "brandy-and-soda" crowd, or, as Janet Beales Kaidantzis put it in *Fallen Leaf: A Lake and Its People, 1850–1950* (2011), "Not everyone visiting Tahoe in the 1880s was there to vacation in luxury." This included the naturalist and Sierra Club founder John Muir. In the early 20th century, noted Bay Area architect Bernard Maybeck and his family became enamored of Glen Alpine Springs Resort to the extent that he worked out a reciprocal arrangement with its owner: lodging in exchange for rustic-style architectural designs.

With greater automobile access to Lake Tahoe, camps, cabins, and rustic cottages proliferated. These consisted of summer camps for young people, such as Camp Chonokis, and rustic getaways, such as Camp Richardson, Zephyr Cove Resort, and motor courts with their semicircle of little cottages for families who wanted a brief Tahoe experience.

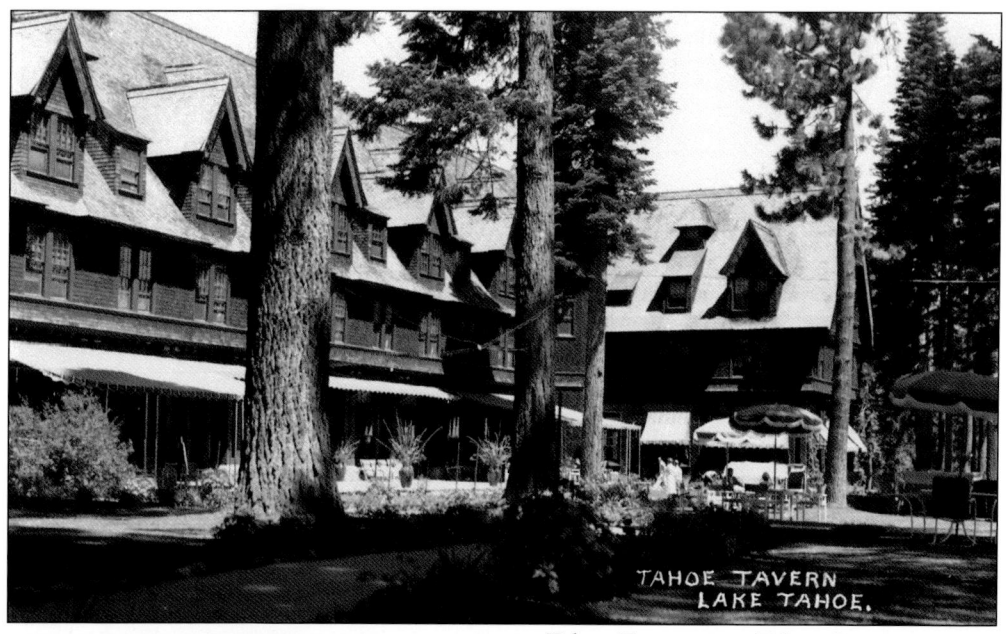

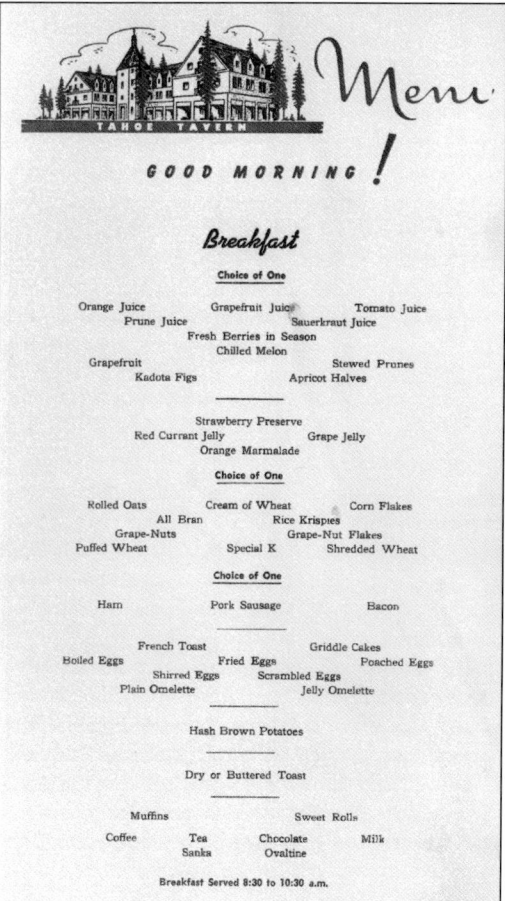

Tahoe Tavern, near Tahoe City, was one of the early-20th-century grand hotels on the lake. It was built in 1901 by lumber baron Duane L. Bliss after his mill and flume operation at Glenbrook closed. His architect son, Walter Danforth Bliss, designed this three-story hotel as a shingle style–resort rustic architectural hybrid, which was then current in fashionable resorts, especially in the Northeast. (UNR.)

This undated Tahoe Tavern breakfast menu features an artist's rendering of the building "completely embowered in pine, cedar, spruce and firs," to quote George Wharton James's 1915 description. James, who advocated outdoor activity while at Tahoe, complained: "One of the chief troubles about a hotel like Tahoe Tavern is that it is *too* tempting." After a breakfast like this, it is easy to appreciate his sentiment. (NLTHS.)

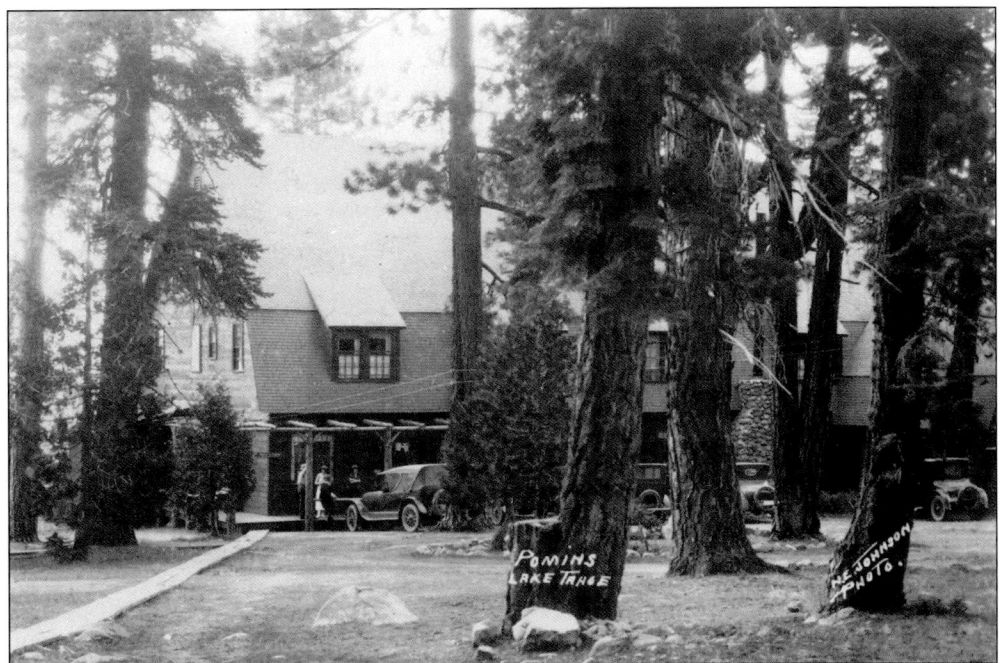

Pomin's Resort near Tahoma was named for Frank J. Pomin, captain of the lake steamer *Tahoe*, and opened in 1914. Edward B. Scott, in *The Sage of Lake Tahoe*, described it as the quintessential Lake Tahoe rustic lodge that "out rustics the rustic." Pomin's Lodge later became May-Ah-Mee Lodge, which was eventually subdivided and is now part of the community of Tahoma. (UNR.)

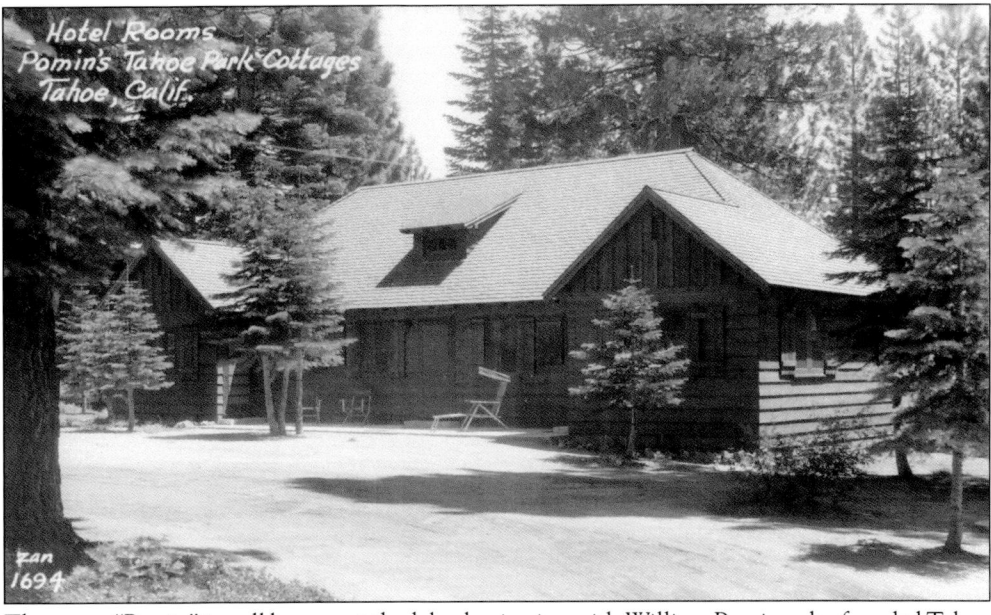

The name "Pomin" is well known at the lake, beginning with William Pomin, who founded Tahoe City and whose daughter (named Tahoe) was the first girl born in the Tahoe Basin. They were a nautical family to be sure, but they were in the hospitality industry as well. This photograph is clearly identified as hotel rooms at Pomin's Tahoe Park Cottages, not to be confused with Pomin's Resort. (LTHS.)

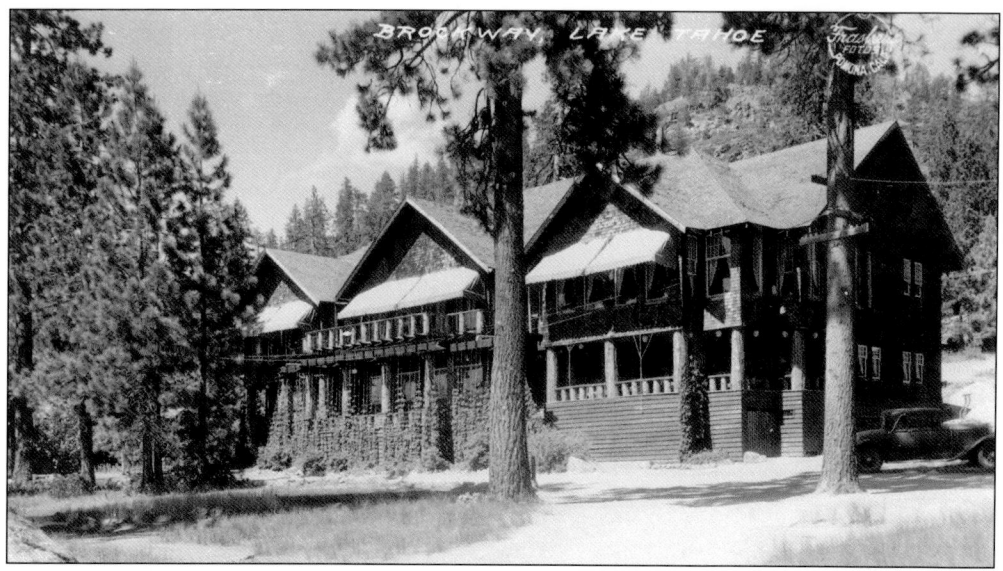

Brockway's Hot Springs was a popular Lake Tahoe resort catering to health enthusiasts. Other springs in the Tahoe Basin, such as Rubicon, Deer Park, and Glen Alpine, had a following too, but Brockway's had the advantage of an actual Lake Tahoe shoreline location. Guests who came to Brockway's drank copious amounts of the mineral water and bathed in the natural geothermal springs. Although the resort dates to 1869, it became Brockway's when Frank Brockway Alverson bought it in 1900. These photographs of the casino–dining room facade illustrate the popularity of rustic architectural elements, in particular the log porch posts and balustrade. Log porch posts were integral elements in many rustic resorts (for example, Tahoe Tavern) and residences (for example, Pine Lodge) around the lake. (Above, UNR; below, LTHS.)

Glen Alpine Springs Resort was one of the earliest in the Tahoe Basin. A Placerville rancher named Nathan Gilmore discovered the springs in 1863 while searching for some stray cattle. He homesteaded in the area, and by the late 1870s, the rustic resort he built around the springs had a considerable following. Gilmore also bottled the mineral water and sold it commercially. (LTHS.)

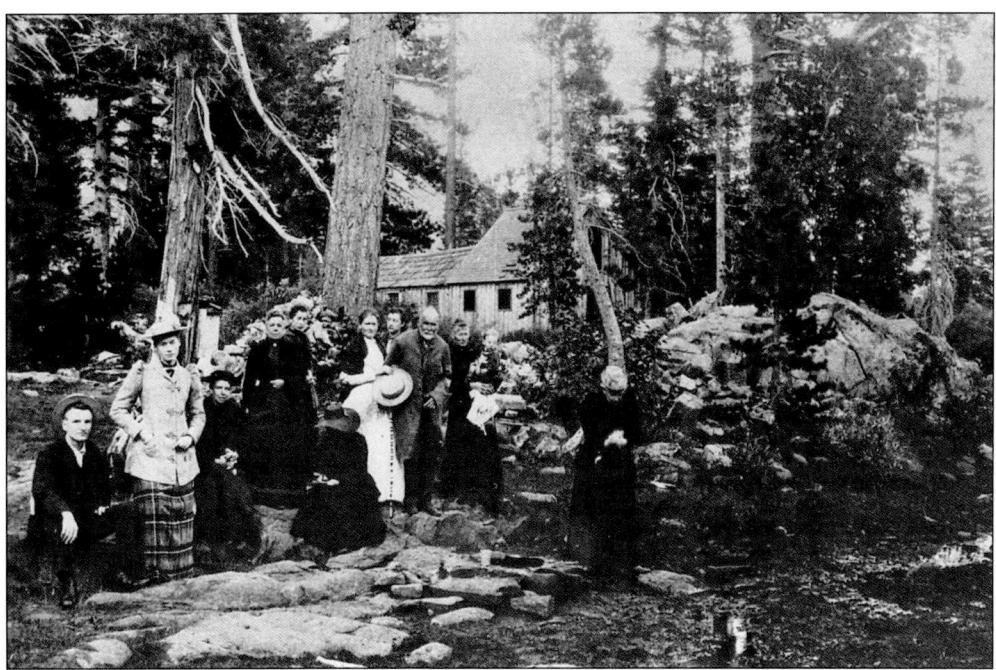

This 1893 photograph shows Nathan Gilmore (center, with beard) and his family at Glen Alpine Springs. Gilmore came west in 1850 as part of the California Gold Rush, but what he discovered instead was the beauty of the landscape above Fallen Leaf Lake. His friend John Muir called Glen Alpine Springs "one of the most delightful places" in the Tahoe Basin. (LTHS.)

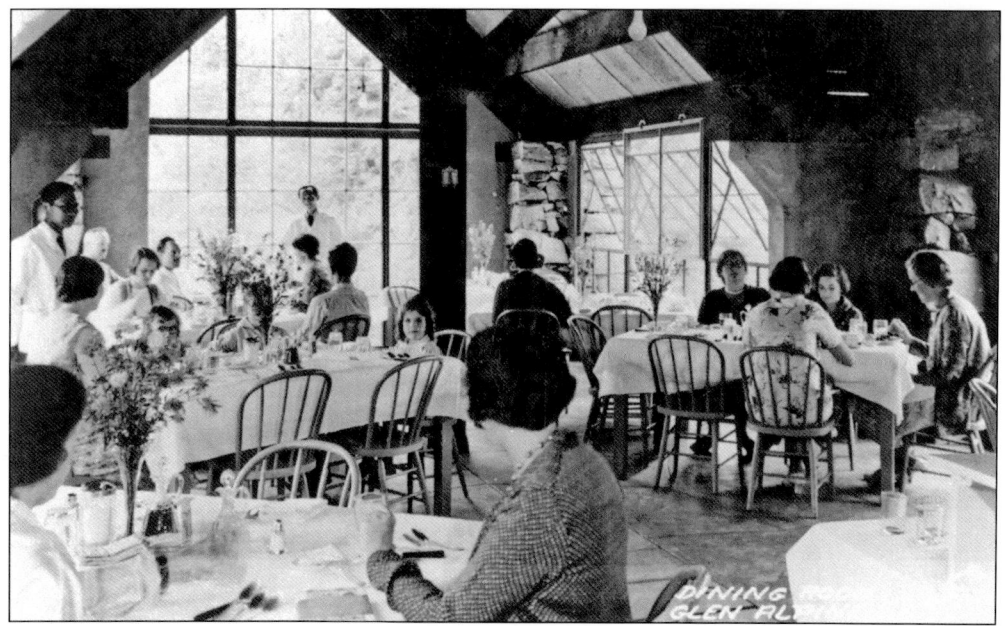

The dining room at Glen Alpine Springs Resort, shown here, was designed by Bay Area architect Bernard Maybeck in 1922. It combined rustic construction (using locally available granite) with elegance in service and table setting (including white-jacketed waiters and wildflower arrangements on every table), as seen in this undated photograph. (LTHS.)

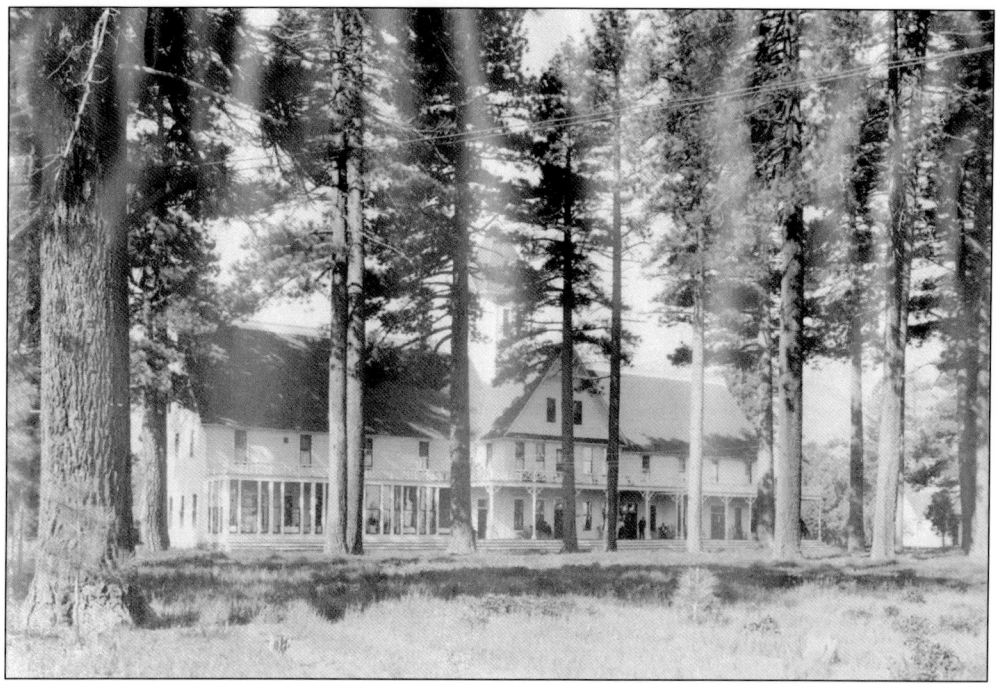

There were several resorts around Lake Tahoe that catered to a well-heeled clientele, and E.J. "Lucky" Baldwin's Tallac Hotel was probably at the top of the list. This photograph shows the "new" hotel around 1902. The property boasted an earlier iteration known as Tallac House, Baldwin's remodel of Ephraim "Yank" Clement's original 1875 hotel. (UNR.)

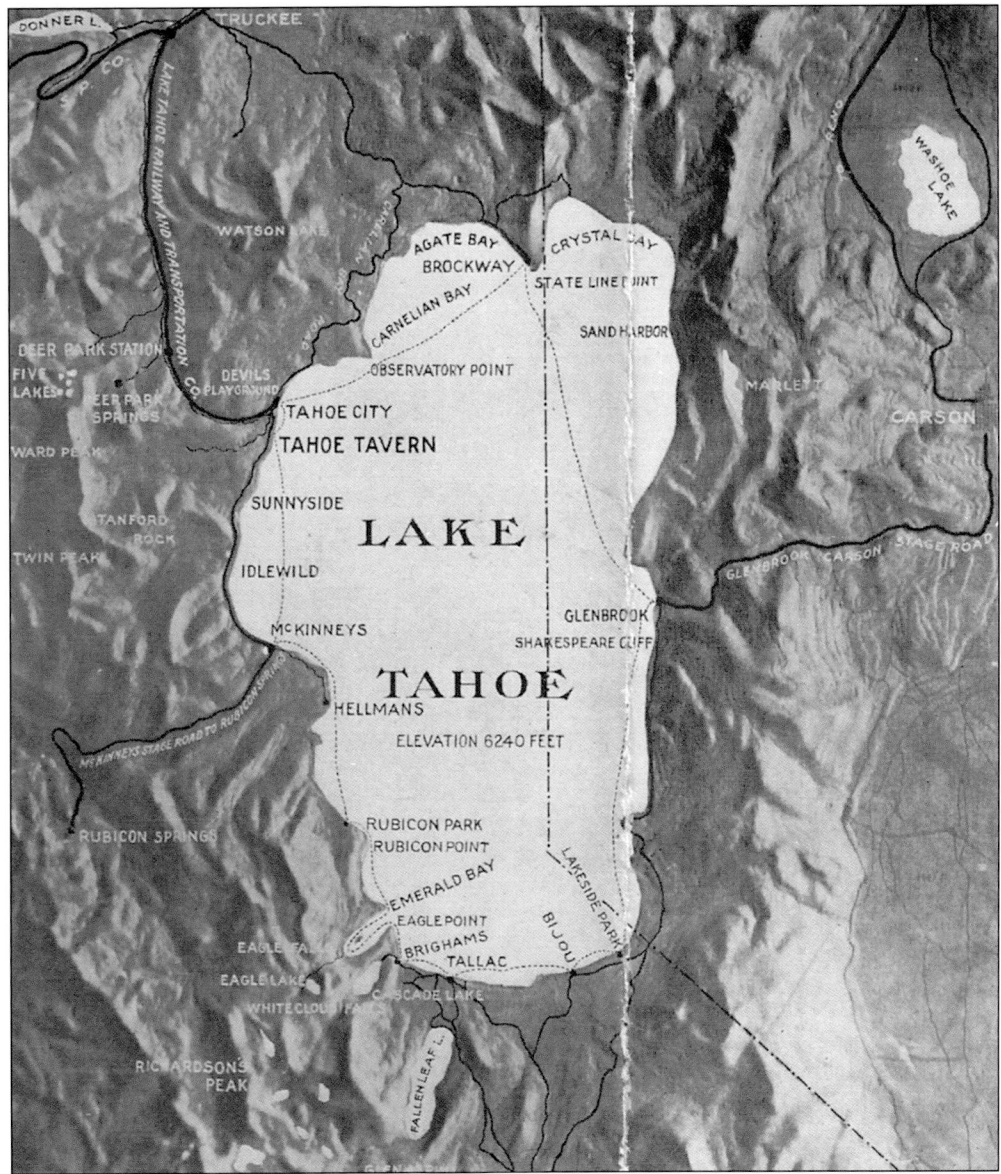

This map appeared on the back cover of a c. 1911 Tahoe Tavern brochure at a time when most people got around Lake Tahoe by steamer. Note the dashed route circumnavigating the lake and the important stops at popular resorts such as McKinney's, Tallac, Glenbrook, Brockway, and Tahoe Tavern, which was also the railroad connection to Truckee. (NLTHS.)

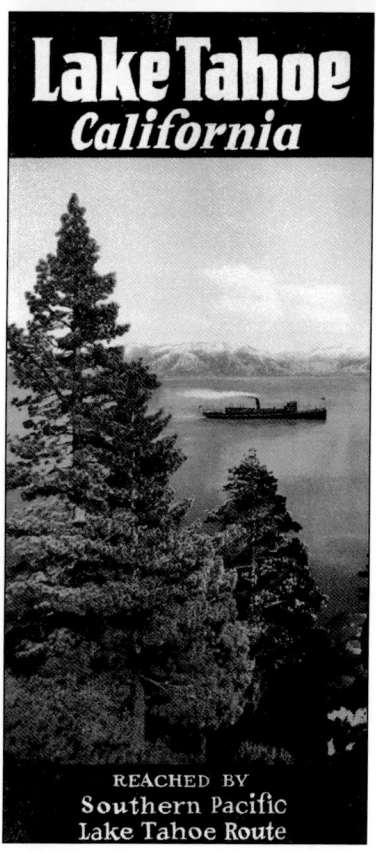

This was how most tourists to Lake Tahoe traveled at the beginning of the 20th century. In this c. 1905 photograph of the Tahoe Tavern pier are the Lake Tahoe Railway and Transportation Company's (LTRT) workhorse locomotive *Glenbrook No. 1* and the steamer *Tahoe*. The building to the left belonged to the LTRT and served as a store and post office. (UNR.)

As can be seen in this promotional brochure distributed by Tahoe Tavern, the combination of railroad and steamer was meant to convey a sense that Lake Tahoe was an accessible destination. The words "Reached by Southern Pacific Lake Tahoe Route" coupled with an image of the steamer *Tahoe* in this 1915 photograph would be comparable to later brochures touting automobile accessibility. (NLTHS.)

One could step out of the Meeks Bay Resort dining room, seen here in 1961, onto what Edward B. Scott described as a "sweeping curve of fine sand beach that runs in a white crescent for nearly half a mile." This rustic building, with board-and-batten walls, shingled gable-ends, and impressive roof, was part of the appeal of the popular resort constructed by the Kehlet family in 1921. (NLTHS.)

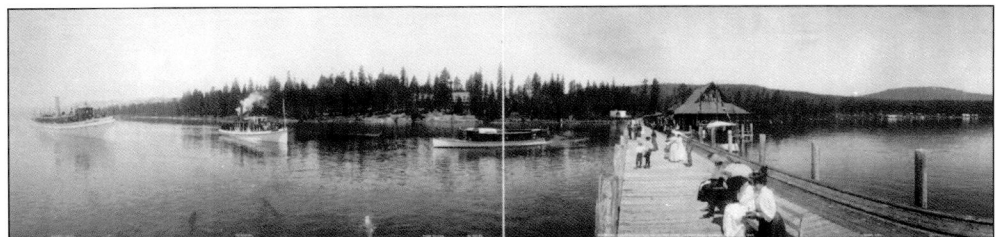

This panoramic view was taken in 1906 from the Tahoe Tavern wharf, which extended an eighth of a mile out into the lake. The vessels, from left to right, are the *Tahoe*, *Nevada*, and *Mi Dueña*. Tahoe Tavern can be seen over the bow of *Mi Dueña*, and Tahoe City appears along the shoreline at far right. (LOC.)

33

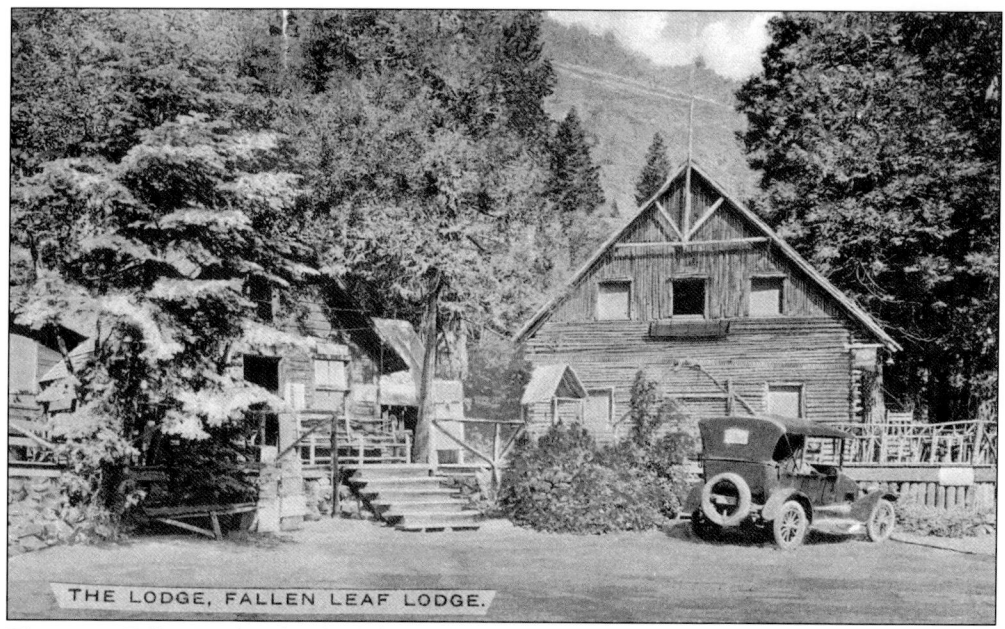

The rustic Fallen Leaf Lodge, built by William and Bertha Price in 1907 and shown in this c. 1918 photograph, particularly appealed to those interested in nature study. The Prices had many friends among Stanford University intelligentsia who populated the 24-room lodge, log cabins, and canvas tents every summer. In the summer of 1925, one of the lodge's employees was a 23-year-old John Steinbeck. (NHS.)

Fallen Leaf Lodge (right of center), on the southwest shore of Fallen Leaf Lake with Cathedral Peak (upper left) looming above, was purchased by the Stanford Alumni Association in 1958 and was renamed Stanford Sierra Camp. Several of the now century-old buildings remain in use, a testimony to William Price's craftsmanship in rustic architecture.

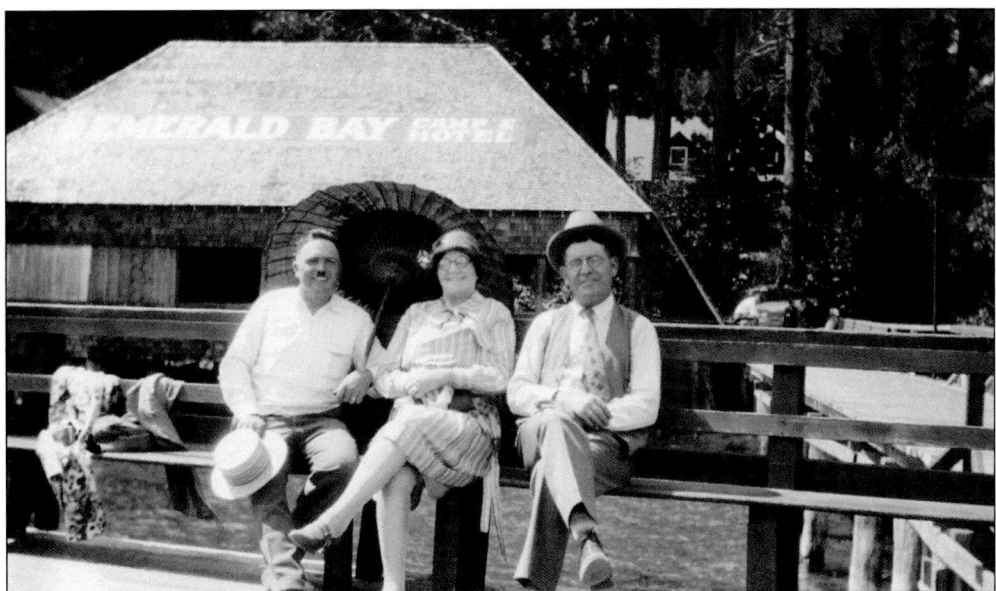

Emerald Bay Camp had a reputation for quiet waters and spectacular scenery. Were it not for a shallow bar, actually a glacial moraine, the bay would be a lake in its own right. Even vacationers staying at other resorts would take day excursions here. The woman in this c. 1926 photograph is Cora Adams. One of the men is Verner Adams, although which is not known. (UNR.)

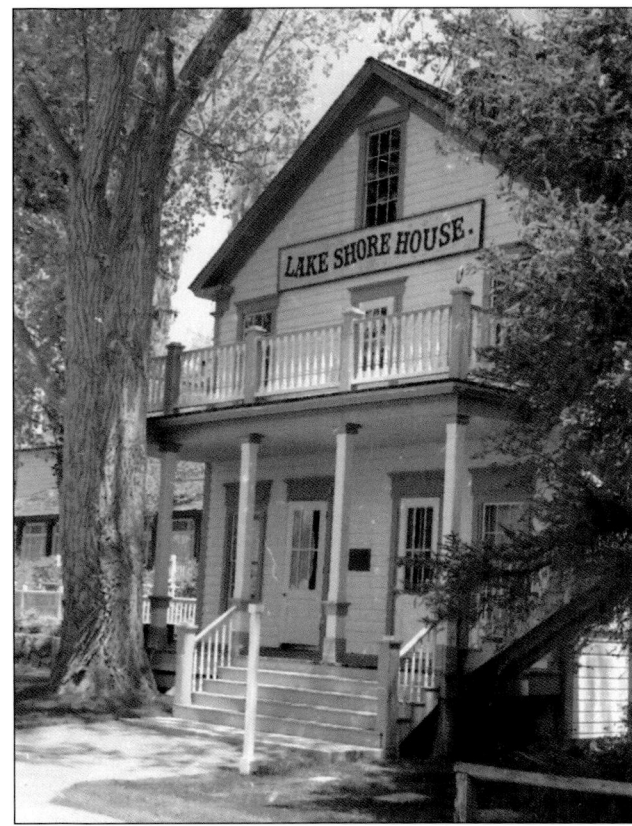

In addition to being a center for industrial lumbering in the 19th century, Glenbrook has been the site of fine hostelries for most of its history. Although this gable-fronted frame building—Lake Shore House—more closely resembles boomtown Virginia City architecture, understandable considering its 1876 date of construction, it later became the south wing of the more rustic Glenbrook Inn, a composite of buildings assembled according to plans by architect Walter D. Bliss. (NSLA.)

This Historic American Buildings Survey photograph shows the entrance to Camp Richardson, named for Alonzo Richardson, who constructed tourist cabins here in 1923. The campground expanded as Richardson bought additional property, built more cabins and a two-story hotel, and offered a variety of goods and services at the camp store. The US Forest Service bought the property in 1974, and the camp remains a popular south-shore resort. (LOC.)

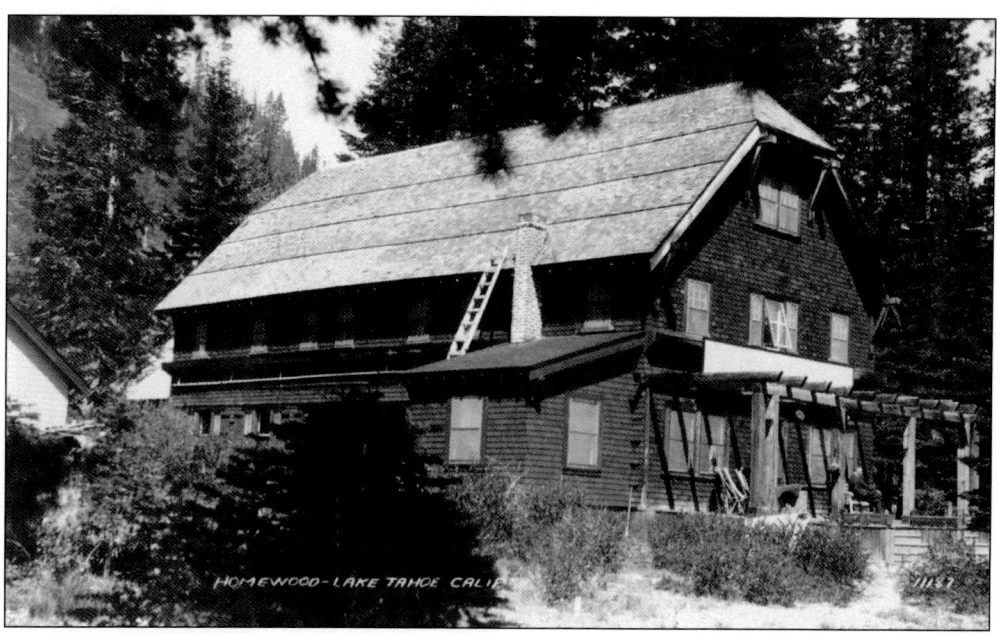

The McKinney Bay resort of Homewood, shown in this c. 1930 photograph, gained its reputation for easy access by the horseless carriage crowd and as a great place for dances. The rustic two-story hotel, with jerkinhead roof, exposed beams, shingled gable-end, and framework pergola, presented an inviting facade facing the lake. (UNR.)

This c. 1930s interior shot of Prusso's Forest Inn on the west shore shows the quintessential rustic dining room, complete with pinecone candle holders on every table. Contributing to its rustic ambiance are log rafters and tie beams, knotty pine paneling, and massive stone fireplace with a planed log mantelpiece, upon which are more pinecones and an Indian basket. (UNR.)

Tahoma, on the south side of McKinney Bay, was a bustling rustic resort according to this 1921 sketch. Opening in 1916, the resort featured a two-story hotel, dance hall, pier, cordoned-off lakeshore pool, and multiple cabins and tent sites. Significantly, this sketch has a caption promoting the resort as being on the Lincoln Highway; the era of the automobile had arrived at Tahoe. (NLTHS.)

This photograph, titled *Lake Shore Cottages of Tahoma Resort, Lake Tahoe, California*, illustrates their simple architecture and physical setting. Note that each cottage had its own deck facing the lake and that there was an absolute lack of landscaping. Even the automobile in the center of the photograph is parked on a slope. (NLTHS.)

Beginning in the 1920s, Lake Tahoe became a vacation destination for those traveling by automobile. Rustic motor courts such as the one shown here proliferated around the lake. They typically had a central lodge-office and a row of small rustic cottages, and in this case, a wonderfully rustic entrance with bent-wood lettering and fencing. (NLTHS.)

The Bijou area along Tahoe's south shore became the location of two well-known resorts: one run by brothers Wilton and Charles Young and the other by Annie and William Conolley. The Young brothers built on property that included the old Bijou House, purchased by their grandfather in 1902, and eventually acquired 33 acres of lakeshore and meadowland. The Conolleys developed property immediately west of the Young brothers. The beach at Bijou was considered one of Tahoe's best; George Wharton James described it in his 1915 guidebook as "clean white sand, with a gentle slope, offering excellent facilities for bathing." These photographs show the rustic Young Brothers Bijou Resort in the 1920s (above) and a view of the resort and its beautiful beach as seen from the lake in 1947 (below). (Both, LTHS.)

Camp Sacramento, located on Highway 50 near Twin Bridges, has been in operation since the 1930s. It is owned by the City of Sacramento and is still a popular summer camp for residents who want to escape the scorching Central Valley summers. This photograph illustrates the adventure of automotive travel in and around the Tahoe region. (NLTHS.)

Some Lake Tahoe resorts were not conveniently located to a beautiful sandy beach, but what they lacked in that regard was often compensated for by an outstanding vista. Befitting its name, this photograph of Bay View Resort, perched above spectacular Emerald Bay, captures many rustic elements of early-20th-century Tahoe resorts, including cedar-bark siding, stonework, and log railings. (LTHS.)

Camp Chonokis operated at Stateline from 1927 to 1953. Two school teachers, Mabel Winter (later Whitney) and Ethel Pope, established this camp for girls in the belief that exposure to the rustic outdoor life would balance the rigors of the classroom. Ethel Pope was replaced in 1930 by Gladys Gorman, a talented teacher from New York who had worked for the YWCA in Russia and Latvia. The camp consisted of the main lodge, shown in the 1929 photograph above, and enough tent cabins to accommodate up to 35 campers. A log cabin that Gorman named Tyschina, a Russian word for peace, was added in the early 1930s. The interior photograph below shows Tyschina's wonderfully rustic living room. Chonokis (meaning "Sugar Pine") is now owned by the US Forest Service. (Both, UNR.)

The Rustic Cottage Resort & Motel on North Lake Boulevard in Tahoe Vista is an excellent example of the many motor courts to be found up at the lake beginning in the 1920s. As can be seen from the sign, it was established in 1925, when automobiles were affordable to a growing middle class nationwide and people had a modicum of what is now called disposable income. The cottages—with names like Brockway, Glenbrook, Spooner, Tallac, and Zephyr—form a horseshoe around the communal center filled with swings, picnic tables, and of course, that icon of rustic lawn furniture, unpainted Adirondack chairs.

This sign for the Washoe Motel on Emerald Bay Road in South Lake Tahoe plays on the Native American back-to-nature theme associated with the lake, although the Washoe people never wore Plains Indian war bonnets, nor did they carry pipe tomahawks. The rustic appearance of the sign, coupled with a Native American theme, however erroneous, is meant to appeal to the Tahoe traveler.

This photograph shows three rustic buildings at Skyland Camp around 1938. Situated on the boulder-strewn slopes between Cave Rock and Zephyr Cove, Skyland Camp featured no-frills board-and-batten lodging with an outstanding view of the lake—hence the name—looking west. Today, Skyland is a small residential area containing upscale single-family homes and rental properties. (UNR.)

These photographs compare the Zephyr Cove Resort as it existed in the 1920s and again on the cusp of the 21st century. Incidentally, this unusual name came from the often-strong prevailing winds that would blow straight across the lake and fill the cove with whitecaps. In *A Short History of Lake Tahoe* (2011), Michael Makley points out that Zephyr Cove was among the early automobile-era resorts forming an arc around most of the lake; "Each maintained a general store and offered rowboats and other amenities." Zephyr Cove today is an active resort with a lodge, restaurant, gift shop, RV park and campground, marina, and beach, operating under a US Forest Service special use permit. (Above, NHS; left, NSLA.)

Except for the automobile—a 1950 Buick Special four-door sedan—and later addition of a deck to the lodge, this photograph of the Zephyr Cove Resort could have been taken yesterday. The view from the beach looking back at the lodge and one of the many rental cabins offers visual testimony to the continued appeal of Lake Tahoe's resort rustic. (LTHS.)

In addition to the architect-designed main house, the Drum Estate at Meeks Bay had several ancillary rustic buildings, including this log cabin photographed in 1929. One architectural feature of note is the relatively low pitch of the roof. Tahoe buildings, both historic and modern, generally have roofs with a steeper pitch, an adaptation to the potential weight of heavy snow accumulation. (UNR.)

The interior of Ed and Mu LeMaire's Lake Tahoe house, Twin Cedars, has a wonderful rustic ambiance, thanks to the open ceiling, knotty pine walls, a warm fire, and comfortable seating, not to mention the taxidermy. This 1952 photograph could well have been taken more recently, insofar as contemporary design includes many of these elements. (UNR.)

Three

RESIDENTIAL RUSTIC

Rustic homes at Lake Tahoe have been built in all shapes and sizes, ranging from the one-room cabin to the architect-designed mansion. By way of contrast, the Hellman-Ehrman Estate at Ed Z'berg Sugar Pine Point State Park on Tahoe's west shore contains both the utilitarian Phipps Cabin (built 1872) and the palatial Pine Lodge (built 1902). This illustrates Tahoe's wide range of rustic single-family dwellings, although strictly speaking, the term may not apply to those mansions like Pine Lodge that had multiple guest rooms and servants' quarters.

Regardless of size, most rustic homes in the Tahoe Basin had another common denominator: they were only seasonally occupied. As such, they were considered second homes. George Wharton James said as much in 1915, when he wrote that Lake Tahoe "has begun to assert itself as a place of summer residence." The second-home nature of most single-family dwellings at Lake Tahoe built prior to World War II exhibited the economy and practicality of the rustic style, especially in interior home furnishings. The rustic style was not thought of as just an exterior fabric or facade; the style was expressed inside the home as well.

Tahoe summer homes of even the wealthy were not lavishly furnished. On the contrary, they embraced the style in furnishing and decor that evoked outdoor sports, Native American and Western heritage, nature study, and the like. This was well illustrated by a home on Rubicon Bay designed in 1939 by architect Julia Morgan for Else Schilling. Morgan was a world-class architect whose clients included William Randolph Hearst, and Schilling was heiress to the family's spice and coffee business empire. This architect-client collaboration resulted in Bow Bay Estate, a wonderfully rustic home inside and out. In addition to the pine paneling and flagstone floor, elements of Tahoe's landscape, the cathedral ceiling gives the interior space a sense of grandeur that may be variously interpreted as towering old-growth timber or cathedral-like peaks; its truss system is reminiscent of an Alpine lodge. A European reference, in fact, was not uncommon in other Tahoe homes, as exemplified by Thunderbird Lodge's Norwegian interior woodwork and the thoroughly Scandinavian Vikingsholm, as well as the many Swiss chalets around the lake.

Hildegard Willman's house is a remarkable example of how Lake Tahoe's rustic architecture often molds itself to the environment. The house is almost ancillary to the boulder-strewn and forested slope, which makes the winding wooden staircase leading up to the house a real necessity. (UNR.)

This 1949 photograph shows the Al Luhr Lake Tahoe Cabin. In many places around the Tahoe Basin, there is little level ground; boulder-strewn slopes plunge to the water's edge, and cabins such as this had to adapt to the contours of the property. Note the difference of a full story between the left and right side of the photograph. (NLTHS.)

Idlewild, a large gambrel-roofed home with gambreled cross gables facing McKinney Bay, was built by Frederick C. Kohl in 1905. In 1926, about the time this photograph was taken, it became the summer home of San Francisco businessman Herbert Fleishhacker Sr. Other decorative elements of Idlewild include the pronounced exposed beams and brackets and the lattice windows. (NLTHS.)

Lora J. Knight's Vikingsholm, built in 1929, is an outstanding example of Scandinavian design in the fjord-like setting of Emerald Bay. Shown here is the conical-roofed tower with first-floor library and second-floor bedroom. The locally quarried granite, mixed with mortar and molded into traditional decorative patterns at the tower's midsection, replicates stone castles Knight had seen in southern Sweden. (NSLA.)

TAHOE CEDARS

Is a subdivision of beautifully wooded lots in the magnificent forest on SUGARPINE POINT

Pomin's New Hotel and Resort
is located here.

I. W. Hellman's Mansion adjoins it on the east.

The commanding view and wonderful timber at once appeals to all nature lovers. It is the one ideal spot on Lake Tahoe to build your Summer home or make your camp.

Opening Prices, $100 to $300
PER LOT

EASY PAYMENTS. NO INTEREST. NO TAXES.

Large Lots, High and Dry. No Swamp or Low Land.

Our Special Free Launch will call for interested parties at any point on the lake by appointment.

Phone or write for reservation.

H. E. CASTLE, SOLE AGENT
POMIN'S HOTEL LAKE TAHOE

This advertisement doubtless prompted some people to buy into the Tahoe Cedars subdivision in Tahoma. The pitch—"It is the one ideal spot on Lake Tahoe to build your Summer home or make your camp"—not to mention the price of $100 to $300 per lot would have been irresistible. (NLTHS.)

According to Edward B. Scott's *The Saga of Lake Tahoe* (1957), in 1925, H.L. Henry was the driving force behind the nearly 1,000-lot Tahoe Cedars tract, and he apparently had a vision: "Several of these were sold to Hollywood notables of the time and other public personages, as Henry intended to start a motion picture colony here." (NLTHS.)

With its porch facing the lake, Pine Lodge's bookend towers and massive stone chimneys add to an overall impression of rustic elegance. It was designed by Walter D. Bliss for San Francisco banker Isaias W. Hellman. Every summer from 1903 until 1965, the family enjoyed life at their Sugar Pine Point estate, which included more than 1,000 acres and nearly two miles of shoreline.

The dining room at Pine Lodge shows why the home is regarded as one of the best examples of rustic opulence in the Tahoe Basin. The table, with several leaves inserted, could seat 30 dinner guests, who must have admired the veneer of handcrafted Dutch ceramic tiles surrounding the fireplace and the intricately woven redwood strips and grass mat on the walls. (NSLA.)

Heir to E.J. "Lucky" Baldwin's Lake Tahoe real estate, including the aging Tallac Hotel, his daughter Anita decided to close the former "Saratoga of the Pacific" in 1922. All the buildings on the property save a few were demolished, with much of the building materials, furnishings, and fixtures being recycled by homeowners around nearby Fallen Leaf Lake, including Anita herself. Anita's daughter Dextra decided to build a summer home on Lake Tahoe at the eastern edge of the former Tallac property. Dextra Baldwin spent summers in this cabin, relocated from the Tallac site, until her 5,000-square-foot rustic home nearby was completed in 1924. In the 1960s, the US Forest Service acquired the property, now part of the Tallac Historic Site, and restoration architects from the National Park Service Historic Preservation Training Center stabilized the building in 2001.

The Pope Estate is one of three that now comprise the Tallac Historic Site on Tahoe's south shore, the other two being the Baldwin and Heller Estates. George A. Pope bought the property in 1923 and dubbed it Vatican Lodge, a playful reference to his surname. This charming log cabin, with its unique bent-wood embellishments, was always a favorite with guests.

In 1923, Walter Heller bought property from his neighbor at the lake, George Pope, and proceeded to build this rustic summer home. He named the gambrel-roofed building with log porch posts and balustrade Valhalla in recognition of his family's Scandinavian heritage. The sidewalk visible at center right leads to a pier and rustic boathouse on Tahoe's south shore.

In Norse mythology, Valhalla is a great hall where the souls of heroes are received. The Hellers' Valhalla lives up to its name insofar as the great hall is of heroic proportions, as seen in this photograph of the massive stone fireplace; its size may be judged by the taxidermy above the mantelpiece. The US Forest Service acquired Valhalla in 1971; today, it is a popular venue for many public and private events. (NSLA.)

Rustic architecture at Lake Tahoe can take on a variety of forms and floor plans, combining natural construction materials in new and innovative ways, as seen in this photograph of the Ebright House. What makes this building unique is the wide wraparound porch, the foundation faced with sticks and stones, and the tree-trunk porch posts with protruding branch remnants. (LTHS.)

This panoramic view of the Eaton Cabin is stunning, not necessarily as an architectural photograph, but for the context of its landscape: the boat at the end of the long pier, the waterfront promenade, the second-growth timber, and most of all, solitude in which to enjoy the ever-changing vista of Lake Tahoe. (LTHS.)

Although recently Lake Tahoe has seen winters with scant snowfall, that was clearly not the case in this undated photograph of the south end of C.O. Valentine's Lake Tahoe home. The photograph also shows the practicality of a gambrel roof. Carlton O. Valentine was a commercial photographer based in Los Angeles in the early 1900s, but Lake Tahoe, for understandable reasons, was one of his favorite subjects. (NLTHS.)

The east shore is less developed than the rest of Lake Tahoe because it was essentially the private preserve of the wealthy and eccentric George Whittell Jr. (1881–1969). He fortuitously got out of the stock market before the 1929 crash, took his estimated $50 million to Nevada as a tax shelter, and ultimately acquired 45,000 acres, including more than 20 miles of shoreline, on the Nevada side of the lake. (UNR.)

This photograph of the north elevation of Twin Pines, a Julia Morgan–designed home built in 1928, shows the profile of an outstanding exterior feature: a substantial log pergola. It was meant to further define the patio space with a rustic accent. Twin Pines is located at Stateline on lakefront property, a nice sandy beach only a short distance away.

The Lena N. Gale Cabin, also known as Good Medicine Cabin, is an example of the middle-class summer homes built at Zephyr Cove in the early years of its development. This one-story-with-loft log cabin was built in 1940 on a 0.7-acre lot. Because it exemplifies the rustic style of so many Tahoe summer homes of that era, the Nevada State Historic Preservation Office nominated the Gale Cabin for inclusion in the National Register of Historic Places in 2001. An interesting feature of the Gale Cabin is the way the tree off the gable end is incorporated into both decks, something not uncommon at Lake Tahoe, where rustic buildings often accommodate their surroundings. (Both, NRHP.)

These undated photographs are of the Tree House, owned by Dr. James E. Church Jr. Dr. Church began his teaching career in 1892 at the University of Nevada, Reno, and is regarded as the "Father of Snow Surveying" for his pioneering work measuring the snowpack on the summit of Mount Rose. Although Tahoe homebuilders are loath to cut down majestic old-growth trees on their property, it is a little unusual to see a tree become the centerpiece of the home. In fact, this large Ponderosa pine, in supporting the conical roof, was obviously part of the architecture. More common in Tahoe rustic architecture is to see a deck wrapping around a tree. (Right, UNR; below, NLTHS.)

Built in 1931, the Withers Log Cabin is a National Register of Historic Places–listed property in Crystal Bay. This photograph of the living room seems to exude warmth and comfort because of the substantial stone fireplace and the rich patina of the logs. This cabin was built as a summer home but is now a year-round residence. (NRHP.)

Four

Architects of Tahoe's Rustic Style

Lake Tahoe's rustic architecture as a whole has not been architect-designed. Although celebrated architects left their imprint at the lake to be sure, most buildings an architectural historian would classify as rustic-style were built by capable contractors in collaboration with those who paid them. In other words, vernacular architecture—buildings and structures built without benefit of a professional architect—was the norm around Lake Tahoe.

The finest examples of architect-designed homes and resorts date from the Gilded Age to the Great Depression. As Lake Tahoe became a popular getaway, especially for the wealthy of the San Francisco Bay Area, summer homes and resorts flourished. Those who wanted something extraordinary hired an architectural firm, often one located, not surprisingly, in the Bay Area. In one case, however, the selection of an architect was simple. When Lake Tahoe lumber baron Duane Bliss wanted to build a grand hotel at Tahoe City, he chose his son, Walter Danforth Bliss.

Any list of architects who have worked at Lake Tahoe would include the aforementioned Walter Danforth Bliss, Frederic J. DeLongchamps, Gustave Albert Lansburgh, Bernard Maybeck, Julia Morgan, and Lennart Palme. Bliss, who trained at MIT and later worked for the New York firm of McKim, Mead & White, designed Tahoe Tavern and Pine Lodge (the Hellman-Ehrman Estate). DeLongchamps was a Reno architect who designed the Thunderbird Lodge for the fabulously wealthy and equally eccentric George Whittell Jr. The Drum Estate's rustic lodge was the work of Lansburgh, whose academic pedigree includes the prestigious École des Beaux-Arts in Paris. Maybeck, also a graduate of the École des Beaux-Arts and mentor to Lansburgh, Morgan, and others while they were students at the University of California, Berkeley, left his imprint at Lake Tahoe at the Glen Alpine Resort. Morgan, who earned her diploma from the École des Beaux-Arts (after being the first woman ever admitted in architecture), designed several modest homes at Lake Tahoe but is best known as the architect of William Randolph Hearst's San Simeon. Palme was a Swedish architect commissioned by Lora J. Knight to design Vikingsholm. Interestingly, all but Palme helped rebuild San Francisco after the devastating 1906 earthquake.

Bernard Ralph Maybeck (1862–1957) is perhaps best known for his design of the 1915 Panama-Pacific International Exposition Palace of Fine Arts Rotunda in San Francisco. For most of his long career, Maybeck was based in Berkeley and even taught at the University of California from 1894 to 1903. In recognition of his contributions, the American Institute of Architects (AIA) selected Maybeck as the 1951 recipient of its prestigious Gold Medal. (UCB.)

In 1920, the Gilmore family sold the Glen Alpine Springs resort property to Edward Galt, who continued its tradition of rustic hospitality. Unfortunately, the following year, the kitchen and dining room were destroyed by fire, a fate not uncommon among resorts at Tahoe. Bernard Maybeck designed this fire-resistant set of buildings as their replacement. (LTHS.)

These are Maybeck's drawings for the Glen Alpine Springs dining room and kitchen. Prominent among the construction materials is the use of local granite "rubble" for walls, chimneys, and especially for the thick buttresses. At lower right is the attribution "Maybeck & White," the latter name being that of his brothers-in-law, with whom he collaborated on occasion. (UCB.)

Born at Glenbrook the son of Duane L. Bliss, Walter Danforth Bliss (1872–1956) was a Lake Tahoe native. Besides his affinity for the lake and the rustic buildings he designed there—Tahoe Tavern and Pine Lodge among them—his architectural legacy is in San Francisco. His partnership with William Baker Faville in 1898 resulted in many fine commissions in the "City by the Bay," including the St. Francis Hotel and the Bank of California. (MIT.)

The Hellman-Ehrman Home, also known as Pine Lodge, was a Bliss and Faville design that combined the shingle and Craftsman architectural styles with a touch of Tahoe. Walter Bliss and William Faville had first-hand experience with the shingle style while both were employed by the renowned New York firm of McKim, Mead & White, which designed some of the finest examples of shingle-style houses on the East Coast. In 1901, San Francisco banker Isaias W. Hellman commissioned Bliss and Faville to design a summer home for his recently acquired property on Tahoe's west shore. The nearly 12,000-square-foot home, completed in 1902, used granite quarried from outcrops on Meeks Bay and local Tahoe timber from Hobart Mills. The sign attached to one of the rustic log porch posts identifies the home as Pine Lodge. (Both, NSLA.)

After completion of the architecture program at the École des Beaux-Arts in Paris, Julia Morgan (1872–1957), a San Francisco native, returned to the Bay Area and opened her own practice in 1904. In a career that spanned a half-century, she designed more than 700 buildings, mostly residential along the lines of the Arts and Crafts movement. Her most well-known work is Hearst Castle at San Simeon, a National and California State Historical Landmark. (JMP-CPSU.)

Situated on the Tahoe shoreline at Edgewood just inside the California state line, Twin Pines is a wonderfully rustic log cabin and guest house designed by Julia Morgan and built in 1928. The main house has a pine-paneled great room featuring a vaulted ceiling with exposed beams somewhat reminiscent of the Morgan-designed Bow Bay Estate on Rubicon Bay. Like many Tahoe cottages, Twin Pines has a massive stone fireplace. A nice rustic touch is the patio with its attractive log pergola. From it, there is an unobstructed west-facing view taking in most of the Tahoe Basin.

Julia Morgan's finest Lake Tahoe design was the Else Schilling summer home at Rubicon Bay, also known as Bow Bay Estate. As the first woman architect licensed in the state of California, many of Morgan's clients were women who rightly regarded her as a successful businesswoman and role model. That included Else Schilling, heiress to the family's spice and coffee business empire. (SHBP-CPSU.)

[Handwritten engineering calculations sheet]

TAHOE RESIDENCE FOR MISS SCHILLING
JULIA MORGAN, ARCH'T. Sept. 26, 1939.

Truss (Span 20'-0")

$R = 60 \times 7 \times 10 = 4200^\#$

$C = 4200 \times \dfrac{20.75}{16.75} = 5200^\#$

$M = 4200 \times 18 = 75600^{\#"}$

Purlin Load = $50 \times 7 \times 3 = 1050^\#$ × 4 = $1400^\#$

M betw. T & ridge = $815 \times 4.5 \times 12 = 44200^{\#"}$

$f = \dfrac{75600}{51.56} + \dfrac{5200}{4.1} = 1470 + 130 = 1600\ ^{\#\square'}$

$T = 4200 \times \dfrac{10}{11.5} - 4200 \times \dfrac{5}{11.5} = 1830^\#$ (4 - 3/4" bolts provided)

Shakes = 5 #/☐
Sheathing = 3
Rafters = 2
—— 10 #/☐

Horiz. project. = 10 × 13.83/9 = 15 1/3 #/☐
Purlins = 4 1/2
 20 #/☐
L.L. = 30
 50 #/☐
Truss = 10
 60 #/☐

Lintel over Window (Span 11'-0")

$M = 3880 \times 2 + 60 \times 4 \times \dfrac{11^2}{8} = 11390^{\#'}$

Used 8" WF 24#

P = 10 × 15 × 7 = 1050#
 45 × 9 × 7 = 2830
 ————— 3880#

W = 60 × 10 × 11 = 6600#

Lintels for Stone

$L = 255 \times 11 = 2710^\#$ (Span 11-0)
 1 L 6 × 4 × 3/8"

$L = 330 \times 4 = 1320^\#$ (Span 4'-0")

8'-0" Span - Dining room windows
W = (600/Roof × 10 + 800/2nd Floor × 10 + 1400/Wall × 10) × 8 = 19400# 8" I 23# 330
10'-0" Span - W = (300 + 250 + 680) × 10 = 12300# 8" I 18.4#

Stone = 75# p.1.f
Roof = 160
Frame = 20
———— 255# p.1.f
 75

Schilling wanted Morgan to design a mountain cottage for her Rubicon Bay property, and Morgan happily accepted the commission. The nine-bedroom, 4,000-square-foot home was completed in 1944. These are some of the engineering calculations used in the design of the home. Note the steep pitch of the roof so common to homes at Tahoe. (JMP-CPSU.)

Gustave Albert Lansburgh (1876–1969), like so many architects working in the Bay Area in the first decade of the 20th century, helped rebuild the city of San Francisco. His passion, however, was the architecture of theaters, auditoriums, and opera houses, and he designed many of them for the Orpheum chain nationwide. Unlike many of his contemporaries, he designed only a few houses, one of which was the Drum Estate at Lake Tahoe. (SFPL.)

The Drum Estate on Meeks Bay, shown in this 1927 photograph, was the summer home of John S. Drum, president of the American Trust Company, who purchased the property in 1923. Noted San Francisco architect G. Albert Lansburgh added some Tyrolean inspiration to this classic Lake Tahoe residential rustic lodge. Interestingly, the lodge was built with cedar from Oregon rather than any of the native Tahoe conifers. (UNR.)

The career of Reno architect Frederic J. DeLongchamps (1882–1969) began with the 1906 San Francisco Earthquake. The city was rebuilding, and DeLongchamps, who initially trained as a mining engineer, apprenticed with a San Francisco architectural firm. He is best known around Lake Tahoe for his 1936 design of the rustic Thunderbird Lodge. However, neoclassical civic architecture was his signature style. (NHS.)

In their book on Thunderbird Lodge, *Castle in the Sky* (2005), Ronald and Susan James explain that owner George Whittell was not easily satisfied and sent Frederic DeLongchamps back to the drawing board with frustrating frequency: "The architect found in the capricious millionaire a client who rejected proposals and tinkered with details." Contrary to this final front elevation, DeLongchamps originally designed a rustic one-story cabin having a moderately pitched hipped roof with clipped gable ends. (UNR.)

George Whittell and his architect finally agreed upon a design for Thunderbird Lodge, and it was clearly more than a simple rustic cabin. As can be seen in this 1936 cross section, the steeply pitched gable roof flanked by random rubble-stone chimneys gives the lodge a vertical feel replicated in other Tahoe rustic buildings but not often to this degree. Note also the truss system designed to be both functional and decorative. (UNR.)

Thunderbird Lodge near Incline Village is unique, just like its owner George Whittell Jr. Whittell spared no expense in the construction of a complex that included the main house, numerous outbuildings and structures, and extensive landscaping. A 600-foot tunnel excavated through solid bedrock connects the house with a boathouse at the lakeshore. Reno architect Frederic J. DeLongchamps was commissioned to design the estate's buildings, and work finally commenced in 1937 after lengthy negotiations with his eccentric client. Most of the actual construction was done by Native American stonemasons trained at the Stewart Indian School in Carson City, Italian ironworkers from the Bay Area, and Norwegian woodworkers who added a Scandinavian touch. Completed in 1941, it is a whimsical example of Lake Tahoe rustic architecture par excellence. The Thunderbird Lodge Preservation Society, a nonprofit organization, now owns and maintains the property. (Both, UNR.)

The interior of Thunderbird Lodge's main house is surprisingly small. There are two bedrooms on opposite ends of the second floor. It is said that George Whittell was something of a recluse; he enjoyed company on his terms, but he did not want a house full of guests. The quarters for employees were located discretely beyond the lodge's main living area. These National Register of Historic Places photographs clearly show the handiwork of Norwegian woodworkers who gave the rafters and balcony a Scandinavian touch, and the ironwork of Italian Bay Area artisans who crafted many pieces—both the purely decorative and the simply utilitarian. (Both, NRHP.)

In the center of this photograph is one of George Whittell's collection of technological gadgets: a state-of-the-art (for its time) movie projector for showing the latest Hollywood films. In addition to his love for fast planes, cars, and boats, Whittell had a life-long fascination with devices such as weather instruments, security systems, and all manner of electronic devices, many of which remain at Thunderbird Lodge. (NVSHPO.)

Thunderbird Lodge is equally famous for its grounds, which everywhere show evidence of Stewart Indian School–trained stonemasons who worked here for several years. They often built at their own discretion and whimsy, and today Thunderbird Lodge Preservation Society docents delight in pointing out these constructions, such as this rustic gazebo on a point of rocks jutting out into the lake. (NRHP.)

One of the unique features of Thunderbird Lodge is a nearly 600-foot tunnel connecting the lodge to a boathouse. Miners who had worked on the Comstock Lode are said to have excavated through solid granite to create this subterranean passage. The floor has tracks for a wheeled cart capable of transporting supplies from boathouse to lodge. (NRHP.)

Lora J. Knight's Vikingsholm on Emerald Bay was designed by Lennart Palme, a Swedish architect married to Knight's niece. Knight had considerable affection for all things Scandinavian and loved the fjord-like setting of the property she purchased in 1928. She and the Palmes traveled to Scandinavia to get inspiration from Norway's wooden churches and southern Sweden's stone castles, and returned to build Vikingsholm in 1929. (UNR.)

Vikingsholm is unique. It can be described as an architect's interpretation of Scandinavian vernacular, but it shares many rustic characteristics with other Tahoe homes. With the exception of stained-glass windows from Sweden (shown in this photograph of the courtyard), all materials were locally obtained. A split-log roof on the west wing, a sod roof on the north and south wings, and a completely unmodified landscape reinforce Vikingsholm's rustic ambiance.

This c. 1940 sketch of a Bijou Pines rustic cottage, part of a larger sheet of inked plans on waxed linen, was probably designed by Piedmont, California, architect Howard E. Burnett. The engaged front porch shows one of the hallmark elements of Tahoe's rustic style: timbered posts that may or may not have retained the bark. (UNR.)

Cecil's Market at Stateline, pictured here in 1946, provides a good example of retail rustic. The unpainted clapboard, multiple small dormers, and steeply pitched roof are common denominators of the style. There is, in fact, a clear resemblance to a resort facade. Unlike many convenience stores and supermarkets today, trees took precedence over parking space. Note, too, the effectiveness of the roof pitch in shedding snow. (UNR.)

This c. 1901 photograph of C.H. Parrish's Bijou House on Tahoe's south shore was taken just before storekeeper Charles P. Young, formerly of Genoa, Nevada, purchased the property. It is an interesting conglomeration, architecturally speaking; from left to right, the two buildings and small ell addition show a range of cladding and construction ranging from board-and-batten to white-painted clapboard and log with cedar shake roof. (NHS.)

Five

Retail Rustic

Merchants provisioning the California Gold Rush, and later Nevada's Comstock Lode, recognized the existence of a substantial marketplace for goods and services. Although costs for goods and their transport could be astronomical, consumers were willing to pay dearly for staples and even for the occasional luxury item. This commerce took place to the west and east of the High Sierra, but beginning in the 1860s, there was a growing demand in the middle, at Lake Tahoe. People were settling in the Tahoe Basin, most only seasonally, but as the timber industry expanded, so too did population.

The earliest architecture for stores, saloons, and the like was often a simple canvas tent on a rudimentary wooden platform, but soon more permanent and substantial buildings were erected. Sawmills in the region made lumber generally available by the 1870s, so frame buildings, often of simple board-and-batten construction, housed places of business. Interestingly, not all the embryonic retailers at Lake Tahoe catered to the terrestrial customer. Capt. Augustus Pray's general store, one of the earliest in the Tahoe Basin, was built on pilings over the water at Glenbrook in response to the importance of watercraft as a means of transportation.

With increased tourism greatly facilitated by the automobile and better road access, several new types of retail businesses began to circle the lake. Gas stations and souvenir stores proliferated, and they often did so with rustic architecture, signage, and decor. In fact, it appears that the rustic image was a marketing tool, or in today's parlance, a brand. Rustic became Tahoe's brand. In his national bestseller *Why We Buy* (1999), retail analyst Paco Underhill says the importance of brand recognition and loyalty cannot be overstated. The extent to which this has continued into the 21st century at Lake Tahoe is an interesting question, and it may be argued that business franchises such as fast food restaurants acknowledge that Tahoe's rustic brand trumps their own. On the other hand, ordinances such as those of the City of South Lake Tahoe govern commercial appearance along scenic corridors and promote "mountain architecture," which they define as "the use of pitched roofs, natural colors, and natural materials such as rock and wood."

Lake Tahoe drains into the Truckee River at Tahoe City, and this c. 1900 photograph taken at that location shows a group of people standing in the doorway of the white frame house that was originally the home of Jeremiah Hurley. It became the Bicose, a shop owned by Amy Cohn where beautiful and highly collectable baskets made by Louisa Keyser, also known as Dat-So-La-Lee, were sold. (NLTHS.)

Beginning in the 1920s with tourists in automobiles circling Lake Tahoe, small stores like this rustic Art Shop in Tahoe City met the demand for souvenirs. This shop specialized in Tahoe landscape paintings, carved wooden objects, and of course, the sine qua non of souvenir shops, postcards. Note how the gabled porch is embellished with the Tahoe brand—rustic logs and bark. (NLTHS.)

As this photograph of the Bijou Gift Shop makes abundantly clear, an important part of Tahoe tourism was having a camera and plenty of Kodak film. In addition to the film, the store also provided postal and Western Union services. Note how the three-part plan of this building was made rustic by incorporating tree-trunk porch posts. (LTHS.)

This c. 1920s photograph taken on the road behind the Tahoma Hotel illustrates how Tahoe retailers catered to the relatively new mobile tourist. Signs visible in this photograph, besides those for the Tahoma Hotel, are advertising what the typical vacationer would want: groceries, drugs, ice cream, barbecue, sandwiches, hot dogs, film, and, on the circular sign at far left, Red Crown Gasoline. (UNR.)

The Inspiration Point Resort, built in the early 1920s near Emerald Bay, was clearly a place where one could stay, have a meal, buy groceries, fill the gas tank, and, according to Edward B. Scott, during the Prohibition era buy "alcoholic concoctions of dubious origins but unquestionable effect." Interestingly, this photograph shows a totem pole used in the 1935 classic *Rose Marie*, filmed at several Lake Tahoe locations. (NLTHS.)

Although the frame of this c. 1936 photograph is mostly filled with the State Line Country Club, it is interesting to see the little State Line Market next door. The board-and-batten building with its modest false front and rustic arcade was evidently a service station as well. The Stateline Redwood Room later replaced the market. (UNR.)

Tahoe City's commercial corridor in this c. 1940 photograph seems to have served locals and tourists alike. In addition to the market with the log curb, the white gambrel-roofed building to the right contained a bakery and the Tahoe Novelty Shop, which offered gifts, souvenirs, and film, as well as fishing licenses and tackle. (UNR.)

W.R. Robertson's Richfield service station, pictured around 1948, apparently did more than cater to the needs of automobiles; it looks like this Tahoe Meadows business anticipated the modern convenience store insofar as it had a coffee shop and even a post office. The building, with its rough stone walls, exposed log rafters, and metal roof, is an excellent example of Lake Tahoe retail rustic. (UNR.)

The rustic store at Fallen Leaf Lake continues the tradition of seasonal entrepôt for the community. In addition to the snacks and sundries offered within, it serves as the local post office (combination lock boxes are on the wall at far right). The photograph shows two artifacts from a bygone era: the sign from Fallen Leaf Lodge and a pay phone (out of order).

The rustic style remains Tahoe's dominant architectural style, especially with more recent commercial core makeovers. The city of South Lake Tahoe's scenic corridor has a plethora of businesses, but the neo-rustic design of shops such as these along Lake Tahoe Boulevard ameliorates what would otherwise be a congested and competitive retail environment.

Even the McDonald's on Lake Tahoe Boulevard in the city of South Lake Tahoe conducts its fast-food business from a building styled as "mountain architecture." In this photograph, corporate signage is comparatively diminutive within the context of rustic architecture and landscaping. Not seen is the absence of a drive-through, something mandated by city ordinance for reasons of air quality.

At any ski vacation destination in the country, there is the expectation of retail shops catering to the sport, and Lake Tahoe is no exception. Located adjacent to the Heavenly Gondola at South Lake Tahoe is a neo-rustic complex of stores, many of which specialize in recreational clothing and equipment.

85

This celebrated "cross of snow" on the northeastern slope of Mount Tallac, as viewed from the Tallac Resort, has its origins as a topographical and meteorological phenomenon. As the most recognized symbol of the Christian faith, people look for the snow cross every year—from the halcyon days of the Tallac Resort to the present—but sometimes in vain because of Tahoe's variable weather. (LTHS.)

Bishop George C. Hunting, the third bishop in the Episcopal Diocese of Nevada, presides at an outdoor altar around 1914 at the original Camp Galilee property, later relocated to the Glenbrook vicinity. Like other secular and religious camps at Lake Tahoe, Camp Galilee is a collection of rustic cabins and other structures situated in a remarkable natural setting. It remains a popular retreat for church members of all ages, especially during the summer months. (UNR.)

Six

Religious Rustic

The association between places of natural beauty and religion has a long tradition in America. This is especially true of camp meetings, which reached their zenith of popularity in the 19th century. Some established camps even resemble miniature communities, with rows of cottages surrounding a central building or tent. Families remain at the camp meeting for a week or more, their days filled with a mix of religious revival and recreation.

Church camps for children and young adults also have a long history in this country. In nearly every respect, they are identical to other summer camps that dot lakeshores from coast to coast. Campers and staff stay in rustic cabins or tents, swim and canoe, go on nature hikes, make arts and crafts, and sit around a blazing campfire at night singing and telling stories. In addition to all these activities, church camps include spiritual fellowship and some degree of religious instruction and worship. Church camps frequently have biblical or Native American names identified by signage at the entrance, as well as names for buildings and cabins.

Lake Tahoe has its rustic religious landscape in the abundance of church camps, outdoor chapels, and churches. Some date to the late 19th century and are associated with the early resorts and clusters of private homes. Others post-date the 1960s building boom in communities like Incline Village and South Lake Tahoe. Although it is less true today, in earlier times, visitors to Lake Tahoe were keenly aware of the spirituality of the place. For many visitors, the sight of Tahoe's natural beauty—its flora and fauna, water and sky, and cathedral-like mountain peaks—was a deeply religious experience. Author George Wharton James expressed this popular sentiment in his classic Tahoe guidebook, *The Lake of the Sky* (1915): "nowhere can man so readily worship God as in the presence of the most beautiful of His works in Nature." It is no wonder, therefore, that Lake Tahoe has its Camp Galilee (Glenbrook), Chapel of St. Francis of the Mountains (Fallen Leaf Lake), and Cornerstone Community Church (Incline Village), among so many others belonging to the lake's religious landscape. Naturally, all have elements of the rustic style.

In keeping with the tradition of summers up at the lake, the rustic Chapel of St. Francis of the Mountains has served the Fallen Leaf Lake community from June to September since 1923. The interior is equally rustic, from the flagstone floor to the exposed rafters. Interestingly, the cross on the altar came from a temporary chapel in San Francisco following the 1906 earthquake.

7655. THE CHAPEL OF THE TRANSFIGURATION IN THE WOODS NEAR TAHOE TAVERN - CAL.

This archival photograph, a beautiful example of Lake Tahoe religious rustic, is the Episcopal Chapel of the Transfiguration on the former grounds of Tahoe Tavern near Tahoe City. While the sanctuary is within the building, the congregation sits al fresco. The chapel made a great impression on author George Wharton James, who said in *The Lake of the Sky* (1915), "Rustic and simple, it harmonizes exquisitely with its surroundings." (UNR.)

These photographs are of the Chapel of the Transfiguration as it exists today. Note the thick stone walls and sturdy buttresses, log roof, Gothic-like fenestration under the gable end, Celtic cross on the roof, decorative chalice in the topmost window, and sign with a rustic pinecones-and-cross motif at either end. The Bliss family donated two acres to the Episcopal Diocese of Northern California, and architect Walter D. Bliss designed the chapel and supervised its construction in 1909. In September of that year, Bishop William Hall Moreland from Sacramento wrote in his diary: "At Tahoe, held my first service in the unique and impressive outdoor Chapel of the Transfiguration just completed."

This South Lake Tahoe First Church of Christ, Scientist has an association with one of the lake's most well known individuals: Lora J. Knight, who built Vikingsholm on Emerald Bay. According to Helen Henry Smith's *Vikingsholm: Tahoe's Hidden Castle* (1973), the church and Mrs. Knight's famous Scandinavian-inspired home have a connection: "Through church affiliations, Mrs. Knight became acquainted with the William Henry Armstrong family who owned 239 acres at the head of Emerald Bay." She bought the property in 1928 and promptly built her home the following year. Mrs. Knight was a philanthropist who generously supported both this Lake Tahoe church and the Christian Science church in Santa Barbara, California.

This photograph shows the South Lake Tahoe Christian Science Society church before the addition of the reading room, an integral part of most Christian Science churches, to the left of the front entrance. It is interesting too that the sign emphasizes year-round services; at Tahoe, evidently, snow does not deter the faithful. (LTHS.)

Designed by architect Jeffrey A. Lundahl and completed in 2000, St. Theresa Catholic Church in South Lake Tahoe is a beautiful example of the new religious rustic in the Tahoe Basin. In contrast to the rustic construction materials and dark brown exterior paint, the multiple stained-glass windows feature natural landscapes in bright hues of blue and green.

This church on the shores of Lake Tahoe actually came from the central Nevada mining town of Goldfield. Built in 1909, when Goldfield was booming, St. John's in the Wilderness Episcopal Church languished in the ghost town that Goldfield became after the precious ore ran out. Reno architect Edward S. Parsons realized that moving the cut stone walls would be prohibitively expensive, so his design called for new concrete-block walls. In 1948, the original roof, redwood paneling, Gothic window frames, and pews were reassembled on site. The large Gothic window now overlooking lake and alpine forest once offered up a much different vista of desert and Joshua trees.

The Queen of the Snows Mission Church has its origins with the 1960 Winter Olympics. Located in Squaw Valley, it is affiliated with Corpus Christi Catholic Church in Tahoe City. The architecture of Queen of the Snows is an excellent example of the A-frame, which became incredibly popular around Tahoe in the 1960s. (LOC.)

Corpus Christi Catholic Church is located south of Tahoe City on Highway 89. It was built in 1911, and, like the nearby Chapel of the Transfiguration, sits on land donated by the Bliss family. The church is a rustic blend of Craftsman and shingle styles, as evidenced by its exposed roof beams and rafters, as well as the shingle wall cladding.

The Episcopal congregation of Tahoe City used the Chapel of the Transfiguration in the summertime, but as year-round residents increased after World War II, they needed a church for all seasons. St. Nicholas Episcopal Church is a wonderful example of adaptive reuse insofar as it began as a surplus building purchased from the Southern Pacific Railroad in 1958.

Our Lady of the Lake Mission Church in Kings Beach is affiliated with the Assumption of the Blessed Virgin Mary Parish in Truckee. Our Lady of the Lake is a solid stone and wood-frame church of classical design situated in among the pines of a Kings Beach residential neighborhood. Like many other churches in the Tahoe Basin, it is of post–World War II (1947) construction.

Hope Lutheran Church of the Sierra, located on the western edge of South Lake Tahoe, began as Shepherd of the Hills Lutheran Church when it was built in 1964. Architect Robert Mason's design is clearly in congruence with the backdrop of conifers. The L-shaped wings bordering the parking lot are administrative and classroom space.

The recently built Cornerstone Community Church in Incline Village, designed by architect Doug G. Eddy, is located on the corner of Tahoe Boulevard and Country Club Drive, but its name has a more spiritual meaning. Facing the street corner, the flagstone wall adorned with a prominent cross and the roof gable with exposed beams give an impression of solidity in both faith and form.

The Kings Beach United Methodist Church, like the nearby Our Lady of the Lake, is located in a wooded residential neighborhood. Except for the crosses on the front and rear gable ends and a little stained glass, the building appears residential. From an upslope perspective, the church's metal roof and muted brown walls resemble many homes in the neighborhood. Once inside, however, it becomes clear that this is a house of worship. The church's wonderfully rustic sign on the corner combines the logo of the United Methodist Church with a stylized Tahoe landscape—conifer, lake, and mountains—and the slogan "Wee Kirk O' The Pines" is absolutely fitting.

Tree-trunk sculpture is ubiquitous in Lake Tahoe's cultural landscape. Most common are the iconic chainsaw-carved bears, but this sculpture of Jesus Christ—with the inclusion of the cross, lamb, and stylized halo—effectively symbolizes Tahoe's religious rustic. It is located in a garden beside Christ the King Lutheran Church in Tahoe City.

One of the most popular recreational pursuits at Lake Tahoe has been sightseeing; in the case of this 1945 photograph, a man takes in a commanding view of Emerald Bay near aptly named Inspiration Point. At the center is Fannette Island, topped by the rustic 16-foot-by-16-foot stone Tea House, part of the former estate of Lora J. Knight. (UNR.)

Since 1911, the US Forest Service (USFS) has been buying property at Tahoe, and the agency now manages approximately 70 percent of the Tahoe Basin. The USFS recognizes that access to public lands for recreational purposes is important. The USFS also has an architectural inventory that includes many rustic cabins, such as the one at Fallen Leaf Lake pictured here. (NSLA.)

Seven

Recreational Rustic

There is a long tradition of recreation at Lake Tahoe. Outdoor activities on the water, shore, or surrounding mountain slopes are varied indeed. Rustic buildings associated with Tahoe recreation overlap with resort rustic to some extent, the difference being that recreational facilities do not have, generally speaking, overnight accommodation as their primary function. Golf courses, marinas, and ski slopes, for example, may have associated or nearby lodging, but the emphasis is clearly on the recreation itself. Regardless of whether it is a "stay and play" (resort) or "play and perhaps stay" (recreation) environment, rustic buildings can be an architectural common denominator. This is also true of many private residences around the lake, especially the large mansions, which have their own pier, boathouse, tennis court, and so forth.

This chapter illustrates a cross-section of Lake Tahoe's recreational facilities with rustic architecture. Their buildings often display rustic architectural attributes on a grand scale: a massive stone fireplace and chimney, an impressive arched-log entrance, or signage that attracts attention within the muted and harmonious parameters of the rustic style. Clearly, some of the built environment around Lake Tahoe does not conform to anyone's conception of rustic, a case in point being the large hotel casinos on the Nevada side of the lake.

Looking at the large hotel casinos today, particularly those on the south shore, it is obvious how much space is devoted to accommodation. Just the term "hotel casino" indicates, through word order, the importance of the former. But it is the casino part—and one may argue that gaming is a form of recreation—that is their raison d'être. They deserve consideration in this chapter because early Tahoe casinos almost universally had rustic origins, as some of the photographs clearly show. For example, the rustic ambience of the north shore's Cal-Neva or the south shore's Harvey's Wagon Wheel came from their respective references to Native American and Western themes. As Michael Makley points out in his *A Short History of Lake Tahoe* (2011), Harvey's, the now iconic high-rise glass and steel hotel casino, had log cabin–like beginnings, with two blackjack tables, three slot machines, and a six-stool lunch counter.

Sightseeing at Lake Tahoe was greatly facilitated by the automobile, and Californians had a name for a popular tourist route: the Wishbone. Beginning and ending in Sacramento, the route went over Donner Pass (modern Interstate 80), along Tahoe's west shore, and returned via Highway 50. Rustic accommodations at a place like Young's Bijou Resort made for a perfect outing. (LTHS.)

Of course, one of the best ways to see the lake has always been by boat. In this photograph, an amiable group of sightseers goes out with Capt. Joseph Pomin (leaning on the lifeboat) for a morning cruise aboard the *Happy Day*. They are leaving the Tallac wharf, with the resort's famous casino on shore in the background. (LTHS.)

Watercraft, motorized and non-motorized alike, have been a popular form of recreation on Lake Tahoe for generations. In the summer months, many little coves such as this one are filled with vessels at the end of their respective docks. Directly above the man standing on the rocky shore is Tahoe's distinctive Mount Tallac. (UNR.)

Naturally, spending time on the water was part of any camp experience, and learning how to paddle a canoe took practice. At the rustic Camp Chonokis in the summer of 1932, these young women are getting the hang of synchronized paddling, and apparently the log on the beach is a substitute for the canoe. (UNR.)

What to See and Do
AT
Lake Tahoe
AND
Tahoe Tavern

Steamer Trip Around Lake
Boating
Lake Fishing
Short Trips by Gasoline and Steam Launches
Hunting (in Season)
for Quail, Grouse, Deer or Bear
Tennis and Bowling
Club House Attractions
River Fishing
Visit to Government Fish Hatchery
Riding and Driving

No Poison Oak—No Rattlesnakes

LAKE TAHOE IS EASILY REACHED FROM ALL POINTS

Designed, Engraved and Printed by Bolte & Braden Company, San Francisco

SILVER TROUT

Recreational fishing at Lake Tahoe has been one of its major attractions, as shown in this c. 1911 Tahoe Tavern brochure. Lake and river fishing are among the activities itemized under "What to See and Do." In what was doubtless a marketing campaign to attract clientele to the rustic Tahoe Tavern, the trout on the facing page was a considerable enticement. (NLTHS.)

By 1920, when this building was constructed, the famous fishing at Lake Tahoe was in serious trouble. The wonderfully rustic Fish Hatchery on the north shore east of Tahoe City became the center of the California Fish and Game Department's efforts to revitalize Tahoe fishing. Interestingly, John Steinbeck completed his first novel, *Cup of Gold*, while working here as a caretaker in the late 1920s. (LTHS.)

In 1975, the old Fish Hatchery became the University of California, Davis, laboratory of Dr. Charles Goldman, "the father of Lake Tahoe ecology." In this photograph of the west and south elevations, the building clearly retains its 1920 appearance, and in terms of historic preservation, the UC Davis Eriksson Education Center, as it is now known, is an excellent example of adaptive reuse.

This was the view from the porch of the Tallac casino when it was called "the marvel of the century." Although today casinos at the lake are limited to the Nevada side, E.J. "Lucky" Baldwin built his recreational "marvel" in 1901, a decade before gambling was outlawed in California. In addition to the cards, dice, and roulette wheel, the casino had a billiard room, bowling alley, and theatrical stage. (LTHS.)

Gambling as a form of recreation enjoyed a turn-of-the-century period of elegance at resorts like Tallac and Tahoe Tavern, but its origins on the Nevada side were much more humble. Gambling (now called gaming) became established as small operations in thoroughly rustic buildings such as shown in this photograph of the Nevada Club at Stateline around 1945. (UNR.)

South shore casinos burgeoned in the 1940s and 1950s, as seen in this late 1950s photograph of Sahati's State Line Country Club, although architecturally they were still clinging to rustic log-siding (left) and frontier-western false-front (right) elements. One aspect of the cultural landscape of the era was that signs were getting progressively larger in order to attract passing motorists. (LTHS.)

It may be difficult to believe from this scene out of the Wild West in front of Harvey Gross's Wagon Wheel Saloon that the establishment would someday be transformed into Harvey's high-rise hotel casino. Seen in this mid-1950s photograph are Harvey's trademark wagon wheel windows (first floor under the words "Dancing" and "Blackjack" on the balcony). (UNR.)

The north shore's Cal-Neva Lodge was literally built astride the state line, but all casino activities took place on the east (Nevada) side of a three-inch-wide painted black line on the floor. The Cal-Neva was built in 1927 by developer Norman Biltz for the landowner Robert Sherman. Biltz chose the rustic style for the lodge—from the impressive log entrance to the interior decor featuring log walls and open rafters, abundant taxidermy, and a constructed waterfall and pool filled with rainbow trout. The Cal-Neva burned to the ground in 1937, but Biltz, who owned the place by this time, was undaunted, and crews worked around the clock so that it was rebuilt in 31 days. (Above, NHS; below, NLTHS.)

A north shore rustic icon, the Tahoe Biltmore's unique sign advertises the hotel casino built by Joseph Blumenfeld and his brothers in 1946 on Nevada Highway 28 at the California-Nevada state line. The massive log tripod supports rings of wooden slats upon which the Tahoe Biltmore appeals to motorists who may be looking for more than just lodging.

A winter recreation synonymous with Lake Tahoe is skiing. This 1940s photograph shows Sky Tavern on the Mount Rose Highway, with the entrance to its rustic lodge advertising a ski shop and emergency first aid. Sky Tavern has seen its share of celebrities on the slopes, but locals know it for its junior ski program, which has operated since 1948. (NHS.)

The Village at Squaw Valley, which now bills itself as a year-round Sierra mountain resort, was part of the site of the 1960 Squaw Valley Winter Olympics. It began as Wayne Poulsen's Squaw Valley Ski Resort in 1949, but a decade later, it could compete with traditional European Olympic venues like St. Moritz, Switzerland, and Innsbruck, Austria. (LOC.)

Lake Tahoe has a number of championship golf courses, but probably none is as well known as Edgewood Tahoe, thanks to NBC's televised American Century Celebrity Golf Championship. Located at Stateline right on the shore (in fact, the western holes cross into California), the golf course and clubhouse opened in 1968. The clubhouse was originally designed by San Francisco architect Shay Zak in a style that was more 1960s and less rustic than what appears in these two photographs. It was subsequently remodeled in 1992 by another San Francisco architect, David B. Mourning. The dominant materials are wood and stone, with cathedral-like windows giving an unobstructed and breathtaking view of the lake.

The television show *Bonanza*, which aired from 1959 (the Comstock Lode centennial) to 1973, brought Lake Tahoe into American living rooms weekly for 430 episodes. Many fans of the fictitious Cartwright family visited the set of the Ponderosa Ranch at Incline Village, also a popular theme park until closing in 2004. The Ponderosa's ranch house continues to epitomize Tahoe's rustic architecture in American popular culture. (NHS.)

Eight

TAHOE STYLE

Although much of this book is written in the past tense describing archival photographs of buildings constructed years ago, it is evident that the rustic style is still alive and well in the Tahoe region. It remains part of the Tahoe brand. For example, the *Tahoe Quarterly* publishes an annual issue with its Mountain Home Award winners. The magazine, with headquarters in Incline Village, regularly runs feature articles on architecture, especially houses built in the "Tahoe style." Other terms now in use include "old Tahoe style," "mountain style," and "mountain modern," but the fact remains that the style is fundamentally rustic despite a greater use of glass and steel.

The rustic style, in fact, can accommodate a number of related forms such as Swiss chalet and A-frame, both of which were extremely popular in the 1960s and are found in abundance around the lake. The inclusion of the Swiss chalet in Tahoe's built environment is fitting considering the alpine parallel, and the form is expressed not only in houses but in motels and restaurants as well. The A-frame multiplied on the landscape around Tahoe as a consequence of the 1960 Squaw Valley Winter Olympics.

Ancillary to its rustic buildings, Tahoe's cultural landscape contains a plethora of gazebos, benches, boathouses, and yard ornaments. During the heyday of Lake Tahoe's rustic resorts—from the Gilded Age to the Great Depression—guests spent considerable time strolling the grounds and otherwise enjoying the great outdoors. Summertime residents and vacationers alike came to Tahoe to enjoy the warm days and cool evenings. Therefore, it is important to note that the Tahoe style was not confined to primary buildings but extended to the property itself. Tallac had a famous stone-lined promenade, Pine Lodge and the Pope Estate had beautiful rustic gazebos, and boathouses at Thunderbird Lodge and the Heller Estate displayed a design complementary to their respective homes. Whimsical yard ornaments carved from tree trunks or burl wood contributed to an overall rustic ambience. Even the ubiquitous chainsaw-carved bear, derided by some as middle-class kitsch, has become a Tahoe icon. Tahoe style, whether expressed in buildings or landscape architecture, has shown itself to be resilient and adaptable and is likely to remain popular well into the future.

The lake's rustic architecture has not been simply for those who visit Tahoe seasonally. Year-round residents have grown up with the style, as illustrated in these two photographs: the Lake Valley schoolhouse in 1935 (left) and Lake Valley School students and their teacher in 1942 (below). The building was originally located at the wye intersection of Highways 50 and 89 in South Lake Tahoe, was moved to make room for a shopping center, and now houses the union hall of Carpenters Local 1789. The brass bell from the schoolhouse belfry is proudly displayed at the Tahoe Valley Elementary School. (Both, LTHS.)

This photograph shows a meeting of the Homemakers Club at the rustic Skyland Camp near Zephyr Cove, July 10–13, 1938. A branch of agricultural extension with the objectives of continuing education and community service, Homemakers Club chapters remain active nationwide. Doubtless few meeting venues today are as rustic and scenic as the one enjoyed by these women. (UNR.)

There is a tendency to forget that many homes around the Tahoe Basin were built in a landscape different from today. Closer examination of this early-20th-century photograph, with its beautiful lakeshore property and rustic Tahoe-style home, reveals a landscape of mostly second-growth conifers, especially along the ridge in the background. (UNR.)

Buildings at Lake Tahoe are inseparable from their physical setting, or in the parlance of historic preservation, their viewshed. Physical setting is so important that the National Register of Historic Places considers it a vital criterion of any building's integrity. This photograph of the view of Lake Tahoe from the front porch of a Pope Estate cabin makes it clear why removing a historic building from its setting compromises its overall integrity.

Modern examples of Tahoe-style rustic architecture, such as the Yount Estate in Crystal Bay, seen here in 1999, perpetuate the breathtaking vistas available to so many because of Lake Tahoe's generally steep shoreline. It is nature's equivalent to being a stadium spectator at a bowl game, except the "field" is 22 miles long and 12 miles wide. (NSLA.)

Shown here is another example of modern Tahoe-style rustic architecture, the living room of the Dreyfus-Park Zephyr Cove Estate, photographed around 1997. The home's arrangement of large, closely spaced glass panes—its fenestration—coupled with an elevated property offers an exceptional view of the lake. (NSLA.)

In the foreground of this 1994 photograph of the Stoll House on Kingsbury Grade are the "building blocks" of the Tahoe style—wood and stone. Although this modern home is wood frame, it is completely compatible with its surroundings in terms of both the natural color scheme and the almost total lack of landscaping. (NSLA.)

This gabled contemporary house in Homewood, photographed around 1994, is interesting as an example of architecture popular from the 1940s to the 1980s. Craftsman influence is evident in the overhanging eaves and gable ends with exposed beams, and the angled, cathedral-like windows are a contemporary architectural element. The boxed chimney indicates the presence of that sine qua non of year-round Tahoe residences, the woodstove. (NSLA.)

In this c. 1994 photograph of a house in Homewood, there is a sense of it being perched on some aerie high above the lake, or at least that seems to be the case with its deck. Although decks are architectural adjuncts to houses nationwide, in the Tahoe Basin, they continue the tradition of outdoor living and relaxation evident in the earliest resorts and residences. (NSLA.)

In any discussion of buildings in the Tahoe Basin, mention of the lake's fragile environment is necessary. Although natural runoff from the watershed's 63 tributaries affects Tahoe's celebrated clarity to a degree, human-caused impacts like building too close to a stream, as seen in this photograph, have caused considerably more damage. Nevertheless, people can still live, work, and play at the lake as long as they remain sensitive to its marvelous ecosystem. (UNR.)

The gazebo, like this rustic example from Pine Lodge, was a popular fixture of many early Tahoe resorts and residences insofar as people came to the lake largely to enjoy the outdoors. It was the perfect place to visit with friends and family, to read a good book, or simply to sit and gaze at the tranquility of the lake or the activity of some resident chipmunk. (NSLA.)

Arguably Tahoe's nicest rustic gazebo is at Thunderbird Lodge. Native American stonemasons constructed the sturdy walkway and foundation on a promontory that offers an excellent view of the lake's north shore. Other features of the gazebo include log posts and, true to form, a conical cedar roof. The light served as an aid to navigation, as owner George Whittell's boathouse was nearby. (NVSHPO.)

Usually the setting of a gazebo was a property's garden or lawn, or in the case of Thunderbird Lodge, a rocky point, but this gazebo was built on pilings over the water. This 1930 photograph was taken from the Drum Estate's pier at Meeks Bay, with several rustic buildings somewhat visible in the woods beyond the beach. Interestingly, the gazebo has stairs leading to the water, perhaps for the benefit of swimmers. (UNR.)

This detail of the Valhalla boathouse shows a combination of the rustic and the ornate, an interesting juxtaposition not uncommon to the early-20th-century Lake Tahoe estates. The cedar-bark cladding covers the entire exterior of the boathouse, while the lattice windows add a decorative touch. (LOC.)

The Valhalla boathouse provides an excellent example of the rustic architecture ancillary to many of the early estates around the lake. These two photographs were taken as part of a Historic American Buildings Survey (HABS) documentation of the Heller Estate. The following quote is from that HABS record: "The Valhalla Boathouse is significant both for its contribution to rustic estate architecture . . . [and] its association with the development of recreation and boating along the shores of Lake Tahoe. . . . Built at an incline, boats could be lowered from the Boathouse along a railroad track and into the water below." (Both, LOC.)

The new Tahoe City Transit Center, designed by the San Francisco architectural firm WRNS Studio, has received rave reviews for its modern interpretation of traditional Tahoe rustic. Photographs of the building were recently featured in a Nevada Museum of Art exhibit, *Tahoe: A Visual History*. Writing for the companion exhibit publication, Colin M. Robertson observed, "WRNS Studio's public transit structure is located almost exactly where passenger trains on D.L. Bliss's turn-of-the-century Lake Tahoe Railway and Transportation Company rolled out onto the Tahoe Tavern pier. Responding to the nautical forms of the lake's historic steamers, the building in both form and function addresses the rich history of publicly oriented transit, asking us to think about the future of transportation in this famous environment now welcoming millions of visitors annually."

The neo-rustic Tahoe style seems to be cropping up everywhere around the lake, even in bus stops. This little cabin-like structure is one of many along a stretch of Highway 28 on the north shore. The heavy stone corner buttresses, cedar shingle roof, and exposed rafters are all part of the Tahoe rustic architectural vocabulary. Note too the bench to the right, whose ends are large slabs of local granite.

The South Lake Tahoe Marriott Grand Residences, which opened in 2002, provide an example of how the Tahoe style is interpreted in modern resort architecture. In the heart of Heavenly Village at the base of the gondola, the neo-rustic design of its Lake Tahoe Boulevard entrance echoes traditional use of stone and dark wood. The mountain lion tree-trunk sculpture provides an additional Tahoe touch.

Just beyond the Tahoe Basin per se, the area around Donner Lake between Donner Pass and Truckee has been a popular resort and summer home location for many years. Recently, some more exclusive developments have been built in the vicinity of Donner Lake. These two 1995 photographs show exterior and interior portions of a typical neo-rustic home on Wolfe Road. The exterior is clearly in the log cabin tradition, with the uniform log diameter suggesting some degree of prefabrication. The interior's living room and cathedral ceiling, shown below in a photograph taken from the second floor, illustrate the dominance of gable-end fenestration and a stone rubble fireplace. (Both, NSLA.)

The Rainbow Lodge, situated on the west side of Donner Summit along the South Yuba River near Soda Springs, has been a popular resort since the late 19th century. It actually began as a stage stop on the Dutch Flat–Donner Lake Road but was converted into a tavern in the 1920s. These photographs show the lodge's rustic front entrance facing old Highway 40 (the precursor to Interstate 80) and a cheerful sitting room adjacent to the lobby. The lodge has beautiful pine paneling throughout, a rustic bar with winter sports posters and paraphernalia on the walls, and 33 guest rooms, including a honeymoon suite. It is a wonderful specimen of rustic architecture in the Tahoe region.

The nearby town of Truckee, California, has served as a major transportation hub for Lake Tahoe since the 1860s. As such, Truckee had its share of rustic architecture, including the Sierra Tavern, billed as Truckee's most popular hotel. (NLTHS.)

Nature is one of the most popular motifs of the Tahoe style. In this photograph, one chimney of Thunderbird Lodge is decorated with ironwork of a squirrel in a tree. This and other zoomorphic representations were made exclusively for George Whittell's Lake Tahoe summer home by master ironworker Antonio Soletti. Soletti and his apprentices fashioned each piece by hand in his San Mateo, California, workshop. (NSLA.)

As the final photograph in the book, it is only fitting to have a Tahoe rustic icon—a bear carved from a tree trunk—wave in salutation. The Tahoe Basin is home to several hundred black bears, and bear sightings are not uncommon. This wooden bruin stands waving to passersby at the entrance of the historic Withers Log Home in Crystal Bay. (NRHP.)

Bibliography

James, George Wharton. *The Lake of the Sky: Lake Tahoe in the High Sierras of California and Nevada.* New York, NY: J.F. Tapley, 1915.

James, Ronald M., and Susan A. James. *Castle in the Sky: George Whittell Jr. and the Thunderbird Lodge.* 2nd ed. Incline Village, NV: Thunderbird Lodge Preservation Society, 2005.

Kaidantzis, Janet Beales. *Fallen Leaf: A Lake and Its People, 1850–1950.* Lafayette, CA: Privately printed, 2011.

Makley, Michael J. *A Short History of Lake Tahoe.* Reno, NV: University of Nevada Press, 2011.

McAlester, Virginia, and Lee McAlester. *A Field Guide to American Houses.* New York, NY: Alfred A. Knopf, 1984.

Poppeliers, John C., and S. Allen Chambers Jr. *What Style Is It? A Guide to American Architecture.* Rev. ed. Hoboken, NJ: John Wiley & Sons, 2003.

Scott, Edward B. *The Saga of Lake Tahoe.* Vol. 1. Crystal Bay, NV: Sierra-Tahoe Publishing, 1957.

———. *The Saga of Lake Tahoe.* Vol. 2. Crystal Bay, NV: Sierra-Tahoe Publishing, 1973.

Sierra State Parks Foundation. *Pine Lodge: A California State Park Treasure.* Tahoe City, CA: Sierra State Parks Foundation.

Smith, Helen Henry. *Vikingsholm: Tahoe's Hidden Castle.* Palo Alto, CA: Privately printed, 1973.

Upton, Dell, ed. *America's Architectural Roots: Ethnic Groups that Built America.* Washington, DC: National Trust for Historic Preservation, 1986.

Wheeler, Sessions S., with William W. Bliss. *Tahoe Heritage: The Bliss Family of Glenbrook, Nevada.* Reno, NV: University of Nevada Press, 1992.

Wolfe, Ann M., ed. *Tahoe: A Visual History.* New York, NY: Skira Rizzoli Publications, 2015.

DISCOVER THOUSANDS OF LOCAL HISTORY BOOKS
FEATURING MILLIONS OF VINTAGE IMAGES

Arcadia Publishing, the leading local history publisher in the United States, is committed to making history accessible and meaningful through publishing books that celebrate and preserve the heritage of America's people and places.

Find more books like this at
www.arcadiapublishing.com

Search for your hometown history, your old stomping grounds, and even your favorite sports team.

Consistent with our mission to preserve history on a local level, this book was printed in South Carolina on American-made paper and manufactured entirely in the United States. Products carrying the accredited Forest Stewardship Council (FSC) label are printed on 100 percent FSC-certified paper.

MADE IN THE USA